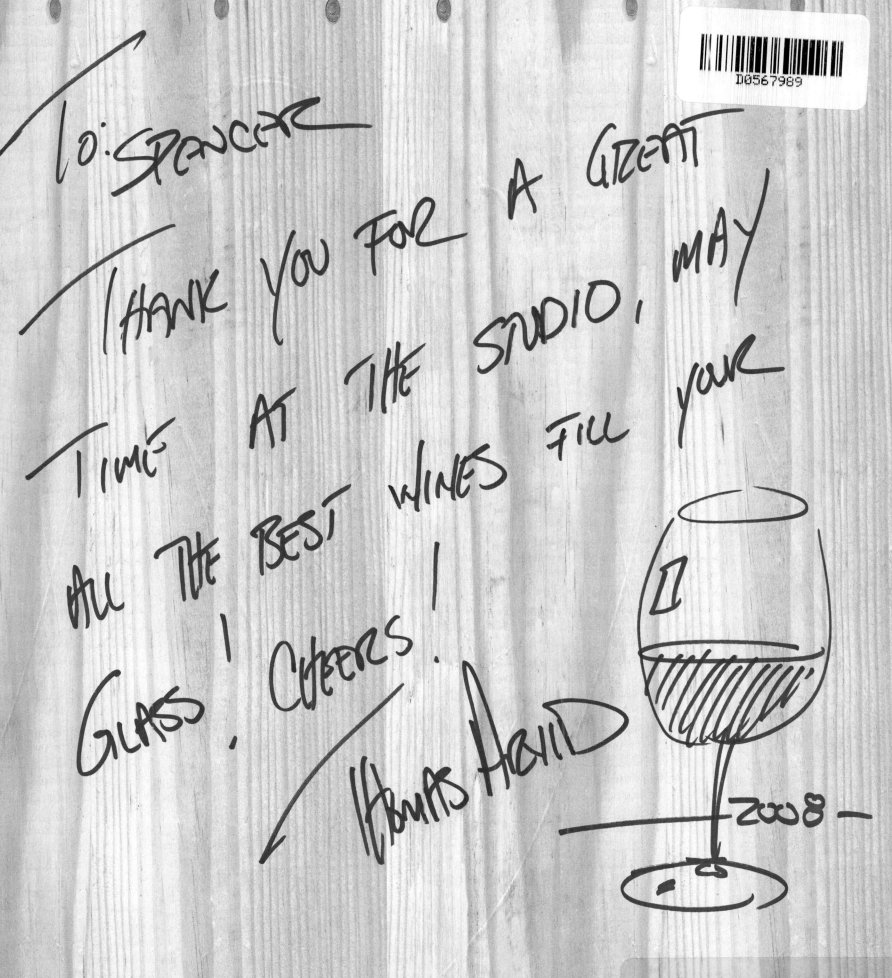

To: SPENCER

THANK YOU FOR A GREAT
TIME AT THE STUDIO, MAY
ALL THE BEST WINES FILL YOUR
GLASS! CHEERS!

Thomas Arvid
2008 —

ARVID

Redefining the Modern Still Life

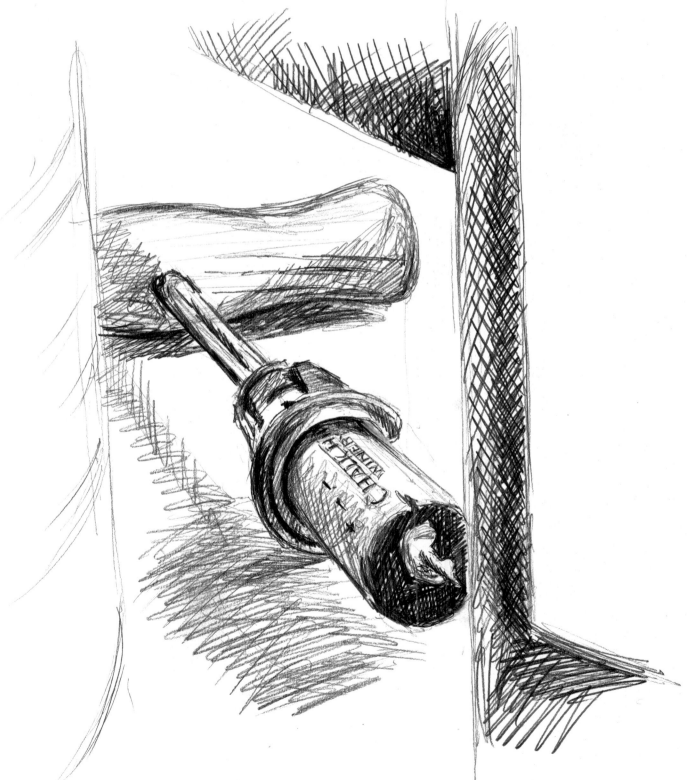

Celebrating a decade of fine art, fine wine and fine living

Project Director/Assistant Editor
Kate Stevens

Editor
Vanessa Arvid

Commentary as told to
Kate Stevens by Thomas Arvid

Production Coordinator
Robert Roberts

Photo Credits
John Haigwood
Dwight Howard
Rob McDonald

Produced by
Dennis Kirk/International Graphics
Scottsdale, Arizona

Graphic Design
Barbara Curry

ISBN: 1-889741-67-1

Printed in Singapore

Acknowledgments

As with any major project, this book came to being because of the support of many talented and generous people. First, I would like to thank the collectors and galleries that have supported Thomas Arvid through the years. A special thanks goes to those collectors (many of them winemakers as well) who spent the time giving us quotes for this book and who opened their homes to our photographer. Thank you also to Elizabeth and Rob McDonald for their efforts collecting those quotes and taking those photographs. I would also like to thank Maria Phillips for her introductory essay. In addition to being the most wonderful Art History professor a young scholar could want—as anyone lucky enough to have attended her classes will attest—Maria is also a talented artist herself. And thank you to Alan Goldfarb for coming to Atlanta, spending time with Thomas and writing the biography. Thank you also to Dennis Kirk and the staff at International Graphics. They have been wonderful to work with, and we really appreciate their patience, guidance and talent.

I would also like to thank the entire staff of Thomas Arvid Fine Art, Inc. for their hard work and support, and for all the extra hours they worked to make this book happen. A special and most heartfelt thanks to Kate Stevens. Kate's dedication to her work and Thomas' kept us on track through the entire process.

And, of course, thank you to our friends and family for all of their support and encouragement.

—Vanessa Arvid
Editor

To all the people who believe in me and my work, especially my wife, Vanessa.

She believed in me from the very start.

—Thomas Arvid

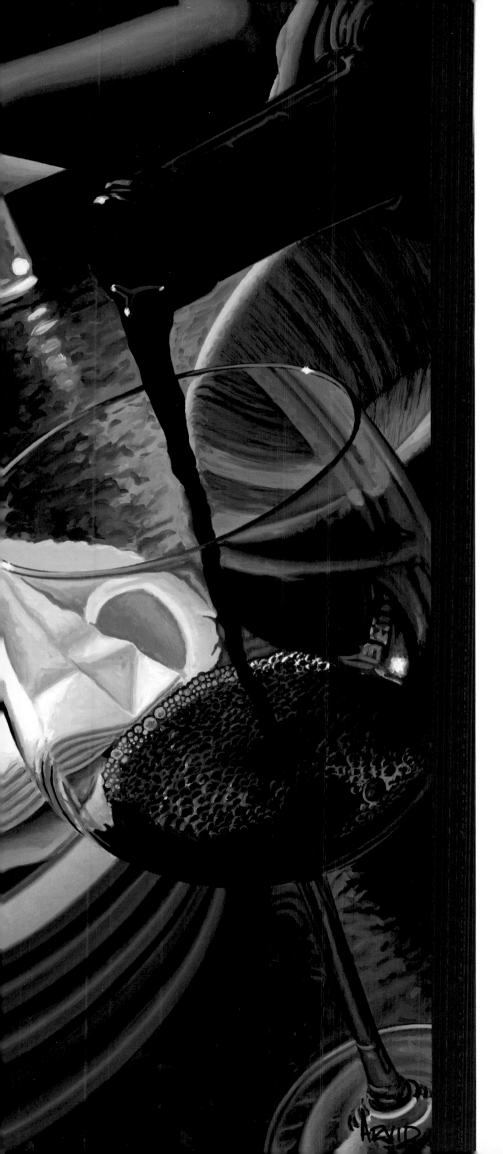

Table of Contents

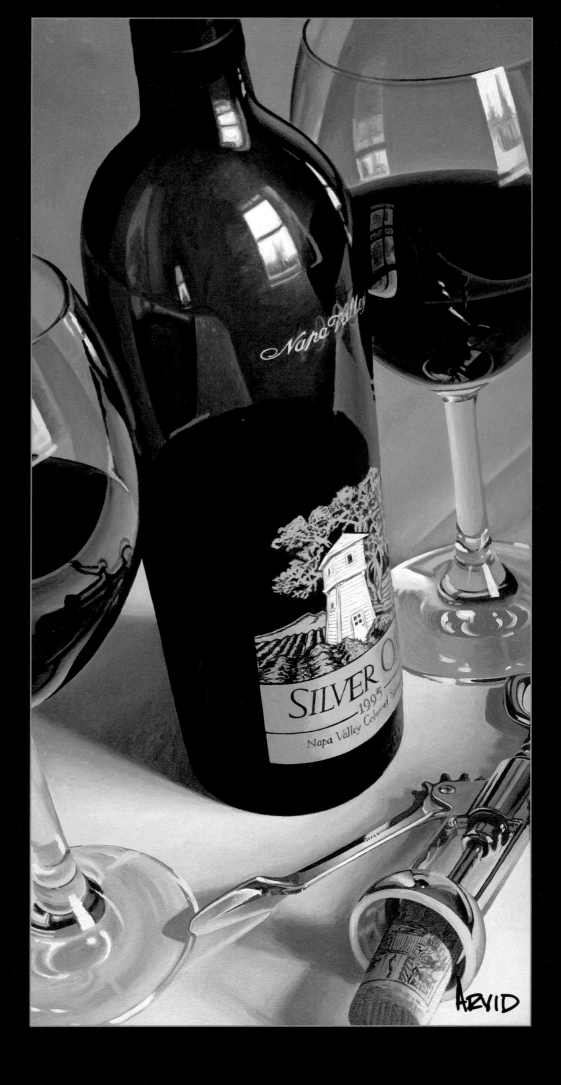

Introduction

By Maria A. Phillips
Art Historian

Thomas Arvid has taken the art world by storm—I venture to say perfect storm—with his large-scale, visually seductive, superreal, photorealistic (they have been called all that) paintings of wine, corks, bottles, bottle openers, glass and glasses. In wine and its attendant paraphernalia, Arvid has found an ideal vehicle for his delight in abundant, rich color. His engagement in the process of painting results in images whose presence transcends the subject matter at the same time as it meticulously describes it. This is the crux of the matter: Thomas Arvid's art is the manifest transition from the physical and the mundane to the intangible and metaphorical. Like a life well lived, Thomas Arvid's wine-laced monumental works are imbued with a sacramental quality that is both an affirmation and a promise.

The scale has much to do with it. Big. The seeming informality has something to do with it too. Things are a bit messy. The glass is half-full; the cork might drip on the table. The point of view? Decidedly odd. From the top or slightly skewed, from the side as if at table. Cut off but reachable. You are there. Who else is there? An intimacy and immediacy reminiscent of some of the most vibrant Baroque altarpieces is established between the image and the viewer and whoever else is hidden behind the picture plane. With this suggested intimacy comes the suspension of disbelief. It's an illusion, we know, but the visual now feels cool and warm and smooth. Transparent. Wet. It's intoxicating. And again it's big, much bigger than life.

The large scale of Arvid's painting is a showstopper. Thomas Arvid knows that the significance of any given subject can be inexorably altered through the handling of the paint and the scale of the image. What is pedestrian when it is life-size can be heroic when it is huge; what is commonplace can alternately be revered or irreverent by the sheer nature of its size. Think of Chuck Close's 1968 *Frank*, that enormous painting of a perfectly ordinary man, close up, with glasses and much too much facial hair; or more recently (2003) Mikel Glass' *Elizabeth Shea*, a "snapshot" in oil of gargantuan proportions: a casually dressed woman on a bed relaxes with her dogs, her light-weight reading material (magazines? sales catalogs?) strewn about her while she rests. These paintings should be photographs out of an envelope from the one-hour photo at the grocery store. But they are paintings! And

Thomas sketching in the first layer of a painting.

they are huge besides. The hugeness adds to their impact. Like Thomas Arvid's pieces, they have presence. They are commanding and demanding. And clearly in demand.

With wine, Arvid has started a trend. Suddenly works by other painters of wine are also in demand, some of them painted long ago, some emulating Arvid's work, some, out-and-out copies. To what can we attribute the quasi-cult nature of the Arvid phenomenon? The fact that contemporary artists have painted wine for at least two decades but that it is Thomas Arvid who has popularized the genre has sometimes been attributed to his love of wine. Or to demographics. Or to America's collective psyche seeking comfort and luxury in uncertain times. Maybe. In the end, it is the work itself, the impact of its beauty, the life-affirming joy exhibited in the making of it that has dictated Arvid's success.

It was clear from the beginning when he was still "performing," as it were, his paintings at Atlanta's Café Tu Tu Tango that his art "had legs." To see it was to want it: the Café provided an avenue for exposure, it was a testing ground for Arvid's practice. He needed no patron to further his activities; he could just paint. And he painted color, red color, in many forms, and one of them was wine.

Then in 1996 Arvid decided to donate one of his wine paintings to a wine auction and fundraiser at Atlanta's High Museum of Art. Just as at the Café, to see it was to want it—and bidders did and paid a goodly price. One could almost say that the rest is history. But that would be oversimplifying, even essentializing, Arvid's subsequent development. In fact, a combination of factors, most of them variable, resulted in that "perfect storm" of my first sentence: enormous talent, hard work, being in the right place and in the right company at the right time, embracing new technologies, taking risks—all this during a period when wine became as big a growth industry as any other in the final decade of the twentieth century. If Arvid has taken the art world by storm, so too wine has taken the country by storm. No longer confined to Europe, nor even to California, Australia, or Chile, wine is now the province of the common American, with vineyards and wine makers and wine tasting events emerging in all manner of dubious-sounding places—wine grapes are grown in Arkansas, Arizona, Missouri, Michigan. And everybody knows that the fundraiser at the local church does best with wine.

The reality is that Thomas Arvid didn't know wine when he started painting it. He knew light and how it's refracted into color. He knew what he saw and what he liked. He certainly liked the color of wine. And he liked to paint it. Coming from a typical American working-class family in Detroit, Arvid is fond of telling you the truth: he taught himself to drink wine just as he taught himself to paint.

In an age when graduate degrees are deemed essential to success, and universities and art schools are producing PhDs and MFAs at an unprecedented rate, when photographer and painter David Hockney stakes his considerable reputation on a new theory that would make the illusionistic productions of the Renaissance and Baroque periods the result of mechanical optical devices, the self-taught Thomas Arvid "performs" his art, lives it, makes a still life move, tricks your eye, and all that seemingly with one hand tied behind his back. Though Hockney's highly controversial theories are convincing in the extreme and in my opinion correct for much of the time, Arvid's innate optical acuity might serve as a powerful argument against them.

Though he needs no mechanical device to project his subject, Arvid's own fascination with optics works together with painstaking observation and planning to create his illusionistic canvases. An accomplished photographer himself, his first step in the design of any painting is to shoot his "models" from various angles and in ideal lighting conditions—this is the phase during which Arvid has been known to chase the light around the studio, moving props and furniture to capture the changing hour. Initially with many rolls of film, now digital memory chips, these photo shoots form the basis of a series of preliminary oil, charcoal or pencil sketches used to block out the positive and negative spaces that abstract the essential elements of his projected trompe-l'oeil fiction. The resulting compositions are not a translation in paint of photographs, they are constructions—Arvid's painted collages seem tailored to prove that point.

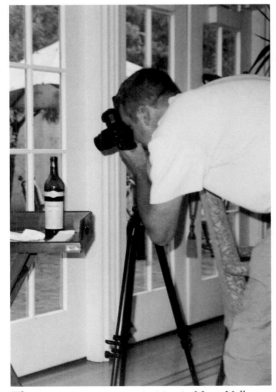

Thomas setting up a composition in Napa Valley.

Once the calculations and compositional decisions are made, Arvid works in the studio under precisely controlled halogen lights to give maximum stability to the painting environment. He reasons that the finished painting will also be illuminated with halogen lights when it leaves the studio. So even the giclée prints are informed by Arvid's more than

casual interest in the way that light affects the reception of color: color correction of the images at the digital stage also needs to consider halogen light to achieve true results.

The giclée process itself with its archival quality inks has come of age at just the right time for Thomas Arvid and his art historian wife, business executive Vanessa Arvid. They first availed themselves of this superior reproductive technique to relieve some of the pressure from the suddenly crushing demand for Arvid's monumental paintings. Or so they thought. It didn't work that way and the demand for the originals only increased with each release. An attendant benefit of this blissfully failed strategy, as Vanessa Arvid is fond of calling it, was the creation of another market for them, this one for limited edition prints. Together, the originals and the giclées form the basis of a rich and thriving business affirming the power both of fine art and reproductive media.

Thomas Arvid paints. His critical fortune has been made not because he paints what he loves but because he loves to paint and paints masterfully and he shows his work and sells it and shares his vision and makes a living at it. That he is able to do this with such integrity and zest suggests to me that this "preeminent painter of wine" is creating in his present body of work a memory of great promise for the future.

———— ⚬⚬⚬ ————

Maria Phillips is a Renaissance art historian with subspecialties in the classical and ancient worlds. She has taught in California and Georgia and won numerous awards, including an American Academy Rome Prize and a Getty research fellowship. Issues of representation and dissemination have been a special focus in her work. The thread that connects all of her activities is a keen interest in the making of art and its impact on building community. Dr. Phillips now lives in Chico, a small town in Northern California recently chosen by John Villani, art and wine critic, as one of the best 100 small art towns in America. Her development as a scholar and observer of art and culture has led her once again to begin painting as well as to do multimedia work, both of these for the documentary and creative outlets that they offer. One of her main endeavors at present is the opening of her new Avenue 9 Gallery, a place dedicated to art and conversation where she intends to introduce a series of Conversations similar to the one she first began in Atlanta in the mid-1990s, On Community and Visual Power. Dr. Phillips is an occasional columnist for her local paper. She is currently writing and illustrating a book of essays based on her life and travels. She and her husband own a vineyard and make wine on their Chico property, Troxel House.

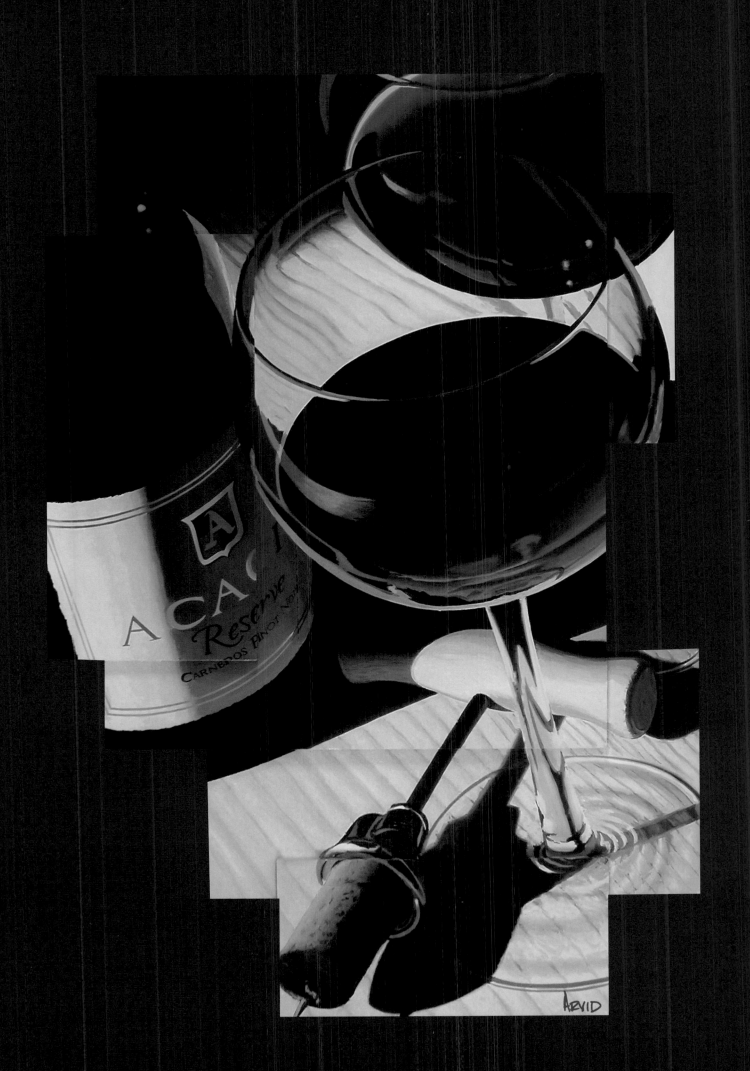

Biography

By Alan Goldfarb
Journalist

Thomas Arvid doesn't own a television because it calls to him, as a spider to a fly, capturing him in a tantalizing web of visual stimulation. To the artist, the electronic medium is so entrancing that as he explores its spectrum of tints, hues and shadings, he becomes so enthralled that he cannot escape, cannot stop watching. He is happily trapped inside the net of color that eventually engulfs him.

Over lunch one afternoon in a sports bar near his Georgia home, Arvid could not divert his gaze from a film depicting, of all things, a football game that was played a half-century earlier.

"There's beauty in this. It's a different kind of art," he says, his eyes transfixed to the soundless box as wisps of breath emerge from players' mouths. "Just look at the scarred, chewed up turf. Just by watching, without words, you can tell the time of year it is, and the temperature in the stadium . . . You try and record it—in your head."

Color and composition for Arvid are at the heart of his work. This fresh-faced young American artist has the capacity to elucidate—figuratively and literally—the soul of wine at precisely the moment it offers up its essence.

What about Thomas Arvid allows him, unfettered and uncompromisingly, to put oil to canvas and create a still life that is so vibrant? It can't possibly be that in addition to his paintings, he's versatile around a stove; and that he's perhaps the only artist on the planet who also performs yo-yo tricks. Which, incidentally, according to his wife, Vanessa, is why she fell in love with him.

Arvid is what Vanessa terms "visually stimulated." "There's something remarkable in Thomas' visual makeup," she insists. "You know how people taste wine and know about wine? It's more than experience. That's Thomas when it comes to painting." Indeed, the artist himself, only 40 years old, concurs that there is something about his makeup that allows him to absorb and convey the gestalt of his subject.

"I see the shape, the size, the color . . . I can see the balance of space, light and texture. Glass, liquid and wood are the hardest things to paint—aside from hands," he says, speaking about the recurring elements in his work. "Glass is not what you think it is. I don't actually paint glass but the things behind it: the contrasting colors of red wine next to translucent green bottles, next to yellow cork. All of these things inform and are informed by the glass. There are multiple facets. We're aware of color—subliminally—but we take it for granted."

Thomas and his brother Rodney.

Thus, he's often asked, how does one make a glass look like a glass? "It's an illusion. What you do on canvas has nothing to do with wine," he answers. "It's fooling the eye. But what it does to people . . . is a feeling of taking them to a relaxed state. That's what keeps you doing what you're doing."

As with any artist toiling in early obscurity, Thomas Arvid's story is quixotic. His beginnings never portended that he would get from there to here. Growing up in Detroit and learning from his father the importance of working hard and providing for family, Arvid didn't consider art to be a career choice.

"I wasn't drawn to it. Being an artist is the last thing your parents want you to do," he says now. "Coming from Detroit, fine art and painting isn't really considered a viable career choice." The closest he came was to work for a printer, painting such things as logos, for others. Later on, he would paint signs, also for others.

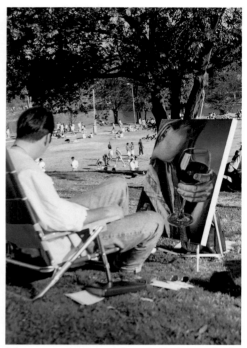

Thomas painting in Atlanta's Piedmont Park, 1993.

Since he had no desire to punch a clock in the waning Detroit auto industry and sensing a deadend in painting signs, he leapt at a suggestion from a friend to take a trip to Atlanta in 1985. Thomas Arvid left Michigan behind.

Two years later, while working for an Atlanta fashion photographer on assignment in Florida, he met Vanessa. Vanessa was one of the models caught in Arvid's viewfinder that day. After the shoot was completed, Vanessa says she took Thomas' shirt home with her, "so I'd have a reason to call him."

Painting, and becoming an artist, however, had not yet taken form in Thomas Arvid's mind. Returning to Detroit in 1990 to care for his father who was ill with cancer, Thomas also returned to painting signs.

After the death of his father, Thomas returned to Atlanta, where he worked briefly as a graphic designer in a print shop. In 1992, Vanessa, by then a budding art historian, convinced him to take an extended European tour. During this tour of the great museums and cultures of Europe, Thomas saw for the first time that being an artist was a viable and respected vocation.

Returning to Atlanta, Arvid went to work as an artist at Café Tu Tu Tango, where he seriously began to view painting as something that would give him satisfaction and his life meaning. At first, he painted people sitting around tables drinking coffee. Then he started painting everything that was the color red: red soup cans, red wagons, red sneakers, red crushed soda cans. One day, a painting of a bottle of red wine on a red and white checked tablecloth was purchased before it was completed. He thinks he got $600 for the piece—quite a sum for an unknown artist. Arvid then painted two more still lifes of wine, and voilà, two more sales. Thomas Arvid, deep in his "red period," found his focus, his raison d'être, and all at once, his métier.

Why red and why wine, the latter of which he knew little? Red is the dominant color in his work. After all, it's the predominant color—in all of its hues

and permutations—of the wine itself in the bottles that he paints, and the wine that he's learned to love and to appreciate. "Red means passion," the artist says. "It's the brilliance of red that makes it a little standoutish."

"Standoutish" is a concept, ironically, that doesn't fit Thomas Arvid. He's the father of two young sons, Jimmy and Christopher. He lives with his young family in a comfortable suburban Atlanta neighborhood. He doesn't fit the profile of the angst-tormented artist, and he doesn't wear a beret or sport a goatee.

As further evidence, and as if it's his mantra, he declares frequently, "I don't want to stand out. I want the work to speak for itself. I try not to look like the artist. I just want the work to gain respect, not by some crazy antics I might put out. There was a right time for that sort of behavior. But the subject matter that I paint now is not funny. People who make wine are serious about it. It's their passion."

Painting wine, and drinking it, is Arvid's passion as well. So comparing himself to a winemaker—a recurring theme—is not a surprise. It's a premise that Arvid adopts quite easily as he depicts the creation of the winemakers' toils and of their craft. But the formation of his labor and of his skill—painting—didn't become Arvid's passion until a series of events occurred. They assured him, imparted confidence in him, and allowed him to realize that he was attuned to something different and special. And that he was talented. The first of two incidents occurred in 1997. While showing his work at an art festival in Birmingham, Alabama, his wine paintings sold out before the show officially opened. Collectors were lined up at his space when he arrived to set up his booth.

Several months later, in Napa Valley, Arvid apprehensively dropped off six of his paintings at a gallery, and left. A short while later, he relates, "They (the gallery owners) called. I thought they were going to tell me I was charging too much and that they couldn't sell anything." Instead the voice on the other end of the phone said they had

Thomas' first oil painting.

15

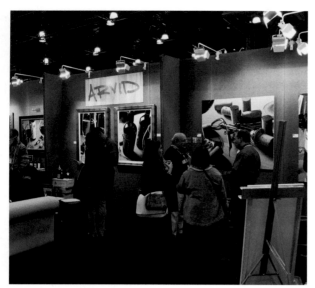

The Arvid booth at Artexpo in New York, 2003.

already sold everything—even before they could hang or frame the pieces.

In 2001, at the largest art show in the country—the annual International Artexpo in New York City, Thomas Arvid's wine paintings began to generate a genuine and palpable buzz. He remembers, "We spent every penny we had to get a good booth," to display his works in the best possible light; to stand out, to be noticed and to be taken seriously. And his paintings sold. They were the only such works at the show. When he returned the next year, there were so many paintings of wine bottles, wine glasses, wine this and wine that, he knew that he had set the standard.

He is so enamored of the craft of winemaking that he likens the process of painting to that of a vintner producing wine. "Am I talking about wine or am I talking about art?" he asks rhetorically. "What I do parallels what people do who make wine. You can't make wine in a day, same thing with art. You can't catch the subtleness, the contrasting elements, in one day." Art is a long, contemplative process. But Thomas Arvid—with the patience and demeanor to wait for one of his paintings to come to fruition—lives the artist's life. "When I sit down to paint, I learn something everyday," he says.

When visiting Thomas' studio, one sees the personal effects with which he's surrounded himself. Never far from his easel, there is a large-screen laptop computer which is loaded with more than 1,000 recordings—mostly blues— whose eight-bar tones of Howlin' Wolf growlin' "Smokestack Lightnin'," or B.B. King pickin' on Lucille and singing "The Thrill is Gone" filter throughout the room.

While he paints, the blues soothe him, eliciting a rhythm and a pace which keeps him at the canvas most days from as early as six in the morning to two in the afternoon. He says it's in these hours of the day that he's most engaged. "Some people wake up slowly. Me, my mind's racing, thinking of projects," he says. "I paint in the morning when I'm fresh and focused."

When he sits in front of a canvas, despite the music, or despite his son Jimmy riding a rocking horse nearby, his work draws him in. "Sometimes," he says, "I get mentally fatigued. Things draw me away. So I go to the garden and water the flowers." Other times, he picks up an acoustic guitar, which sits at arm's length from the canvas, and he begins to strum. "It's one of those things that keeps me in my seat," he explains. "I don't know much about playing guitar, but it lets my painting talk back to me." Placing the guitar back on the ground nearby, his painting in progress soon beckons him back to the easel.

Although he may have 10 or 12 works in various unfinished states of progress going at once, he's not a prolific artist. "I paint all the time, but my paintings are a long-term process," he says. "I paint and I layer. The way oils work, I put a layer on in order to capture the details of the things next to each other, and to see how they relate to one another. It's a process that builds."

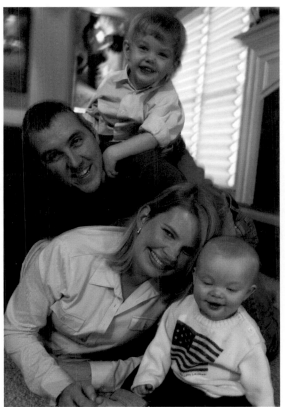

Thomas, Jimmy, Vanessa, and Christopher Arvid in their suburban Atlanta, Georgia home.

That process can be construed as a metaphor for the growth of the artist. Does Thomas Arvid believe he is true to his craft? "A true artist," he elucidates in his humble manner, "is somebody that creates his own ideas and can show the world something that's never been seen before. A true artist believes in his own work. If you do Rembrandt paintings, are you an artist? No. You are a painter. But you're not doing anything for the world."

"I'm aware that I've done something different. When I first started doing this, it was something I stumbled on to . . . but maybe what I'm doing today is a little more than even I think."

The development of the artist's company, Thomas Arvid Fine Art, Inc., mirrors the success and convictions of the artist himself. Thomas describes how it all began with a bemused grin, "It was only 10 days before the show [Décor Atlanta 2000] when they called to tell me that a space had opened up. Vanessa thought that I was crazy to say yes, she thought we weren't ready, that we needed more

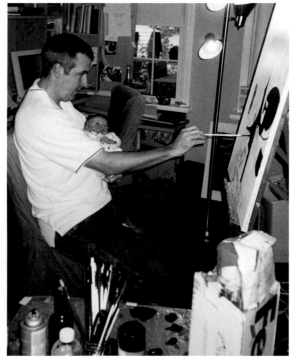

Thomas and Jimmy at their first home in Smyrna, Georgia, 2001.

time to prepare, to polish. I just wanted to jump in; I knew that if we waited for 'the right time' or 'the right place' we would always be waiting. So we did what it took, and look where it got us."

Where it got them is a cozy log cabin nestled in the North Georgia woods just a couple of miles from their home. "The Cabin," as it is referred to by the Arvids and their staff, appears simply to be a suburban retreat tucked away on a couple of wooded acres. Wraparound porches and garden nooks complete the setting of pastoral bliss.

Inside, the cabin bustles with activity; it is the headquarters of a busy and growing company. Far from the rickety shack conjured up by the term, "The Cabin," the interior is a spacious, well-appointed and comfortable home that you might expect to visit in any secluded resort area, or even Napa Valley. Bedrooms have become offices and studios, and the entire basement has been converted to a space designed specially for proofing, storing and shipping the high-quality limited editions that have been so integral to the company's success.

A modern chef's kitchen and luxurious master suite make the cabin an ideal spot for hosting out-of-town guests or fabulous wine dinners. With a business

Headquarters for Thomas Arvid Fine Art, Inc.

and a body of work that is built upon the concepts of gracious and pleasurable living, Arvid has managed to embody those themes even in the space where he works. "Most of all, I want it to be comfortable, want it to be a space where people are happy to go to work. Everything should feel good, otherwise you can't create something that makes other people feel good."

That is what Arvid does—he creates art that makes people feel good, makes them remember special times and moments in their lives. The growth of the company continually brings the work to new and unexpected places, touching people as far away as Australia and Japan. "I never went out of my way to shape the business. Each step brings new challenges that you answer the best way you know how, with integrity and honesty. That is the way to do business, because it comes back to you in so many ways."

He hesitates a second to contemplate the far-reaching question of whether or not he's satisfied with what he's accomplished. "I love what I do!" he answers with a broad smile. "It feels good to do it. It makes people feel good. I sleep well at night."

Thomas and Vanessa relax on the porch of "The Cabin."

Though located in a busy suburb, wooded acres give "The Cabin" a secluded feeling.

"Wine, like food, is an art," he continues. "People who appreciate opera, theater and literature tend to appreciate all forms of art. They are moved by my painting because it speaks to them directly about another part of their lives. My art has bridged them from music and theater and wine to art. When they see my paintings, it doesn't need to be explained to them. It is part of who they are."

And with this book of his work, Thomas Arvid is now a part of who we are.

—⁊⁊⁊⁊⁊⁊⁊—

Wine journalist Alan Goldfarb has been studying, collecting and writing about wine for more than a quarter century. He is the Wine Editor for the <u>St. Helena Star</u> in the Napa Valley in which his focus is on wine and agriculture. His work has appeared in more than twenty-five international and national publications.

A table setting at a fundraiser for the Atlanta High Museum of Art that was held at "The Cabin."

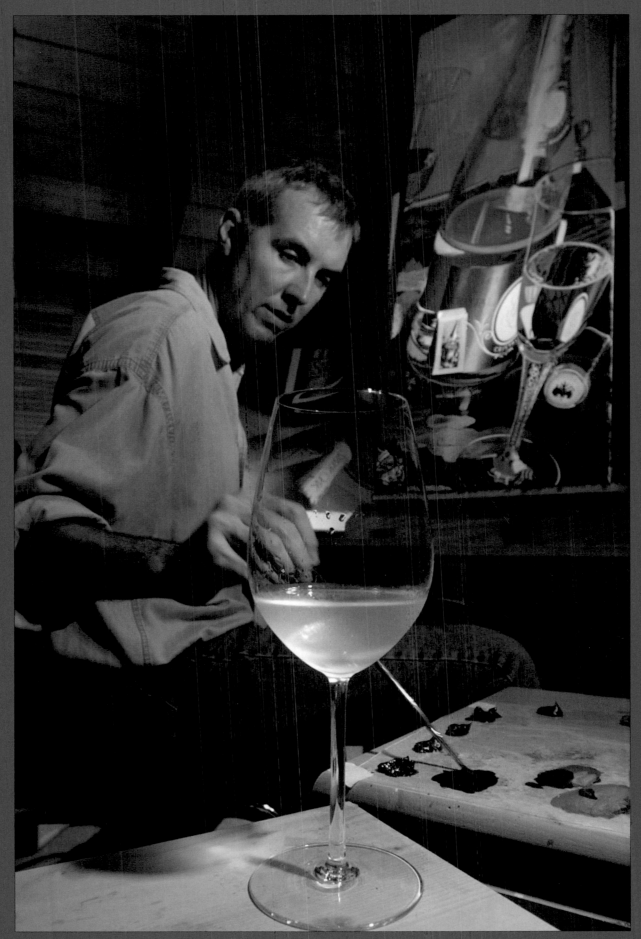

Thomas painting in his studio at "The Cabin."

Reflections

My ability to paint and capture the reflections in this piece really surprised me. I was concerned that I was going a little over the top with realism—but I realized that I was just taking it to a different level. I wasn't painting wine anymore; I was painting the room that you see in the bottle. Reading the reflections adds a whole new dimension to the piece.

ARVID

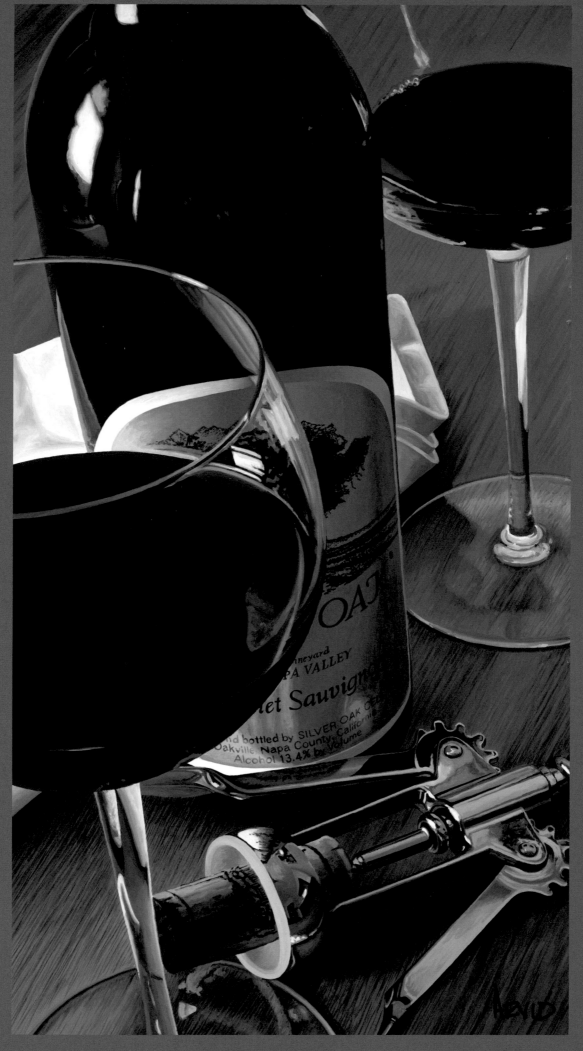

Bonny's Vineyard

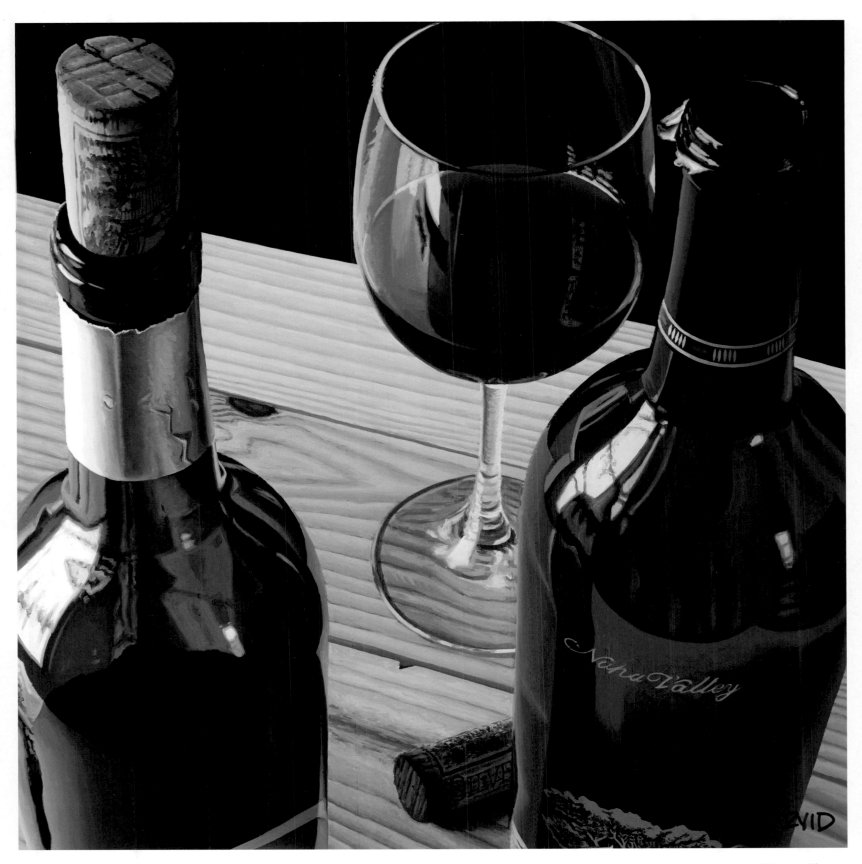

Two to Choose

I see this piece as where it all began for me. It really struck a chord; it was a wine painting in a casual setting, a break away from the stiff, formal still life. The paintings were big, larger-than-life, abstract and interrupted, and people responded to them because it spoke to their experience of being there. Looking at this piece is like seeing a part of my life from so long ago: I see my desire to paint something like no one else had done. I knew that pursuing this original idea was who and where I wanted to be.

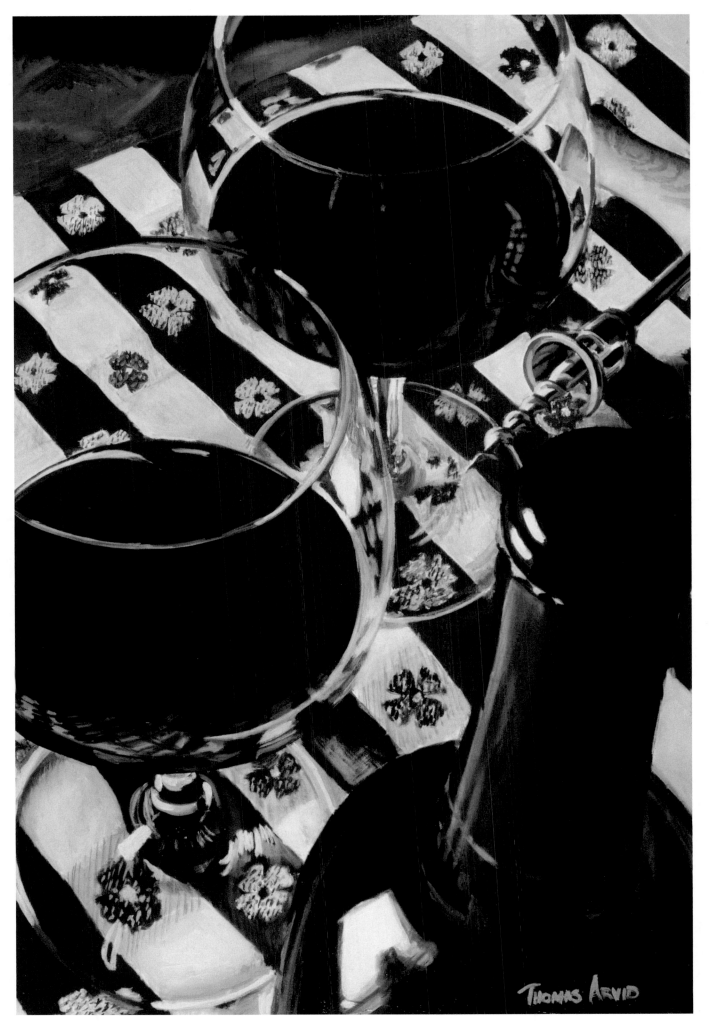

Red & White Table

The label on the bottle reads:

03271
CLASSIC
ORIGINE
ARANTITA

Title Unknown

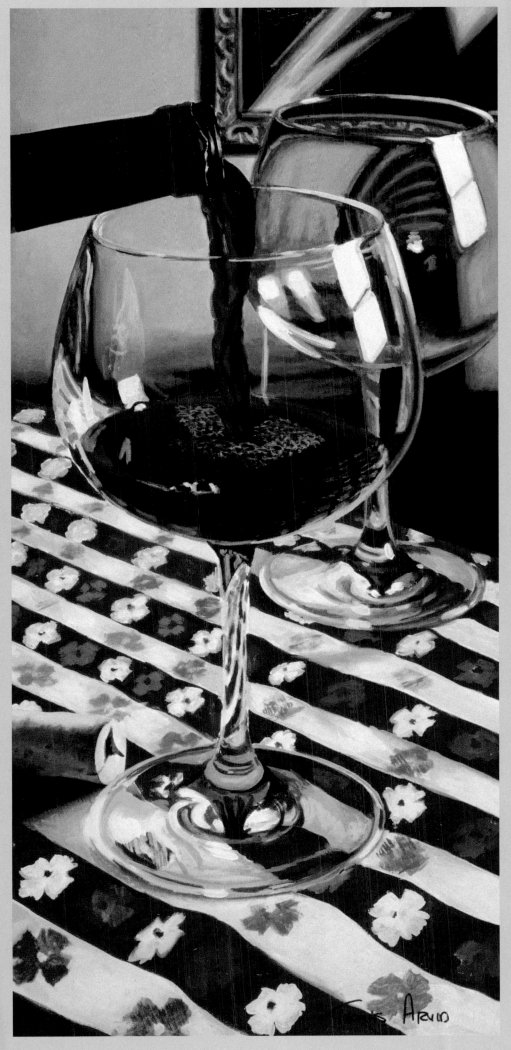

The Pour Red & White 29

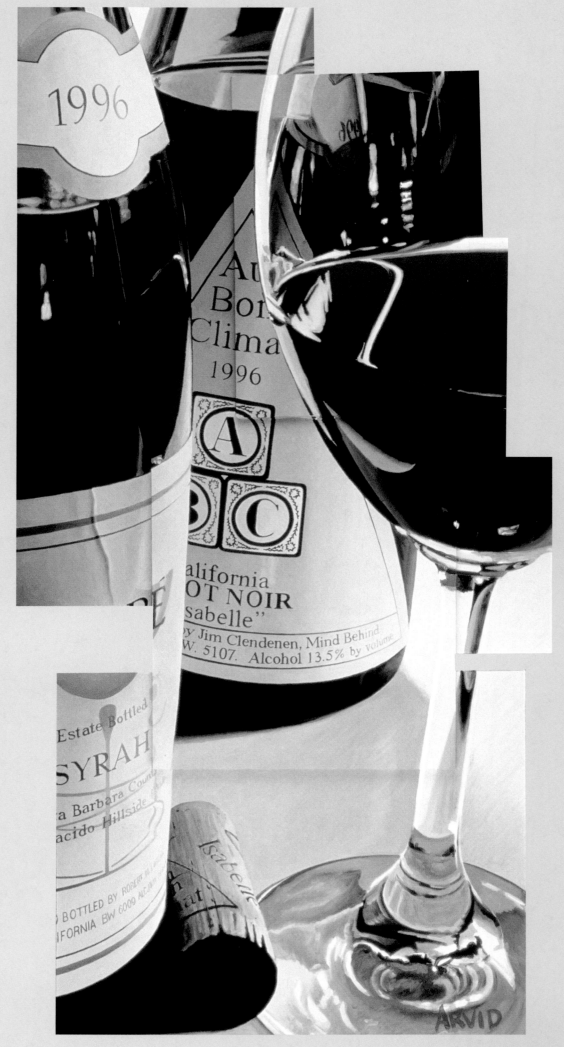

I started doing collage paintings, which are large canvases made up of several smaller canvases fastened together, for a couple of different reasons. Because the subject matter is so traditional, and created with traditional materials—oil paints on a four-sided canvas—creating collages allowed me to experiment and reach toward a more progressive idea artistically. They allow me to literally "paint outside the box." As an artist, I'm always looking to stretch, looking for a new direction.

Also, collages allow me to develop compositions that don't fit traditional canvases. A composition might not work well with four sides, but with a collage, I can void certain areas and extend others. They're meant to be viewed from a greater distance; the closer you get, the more abstract they are.

ARVID

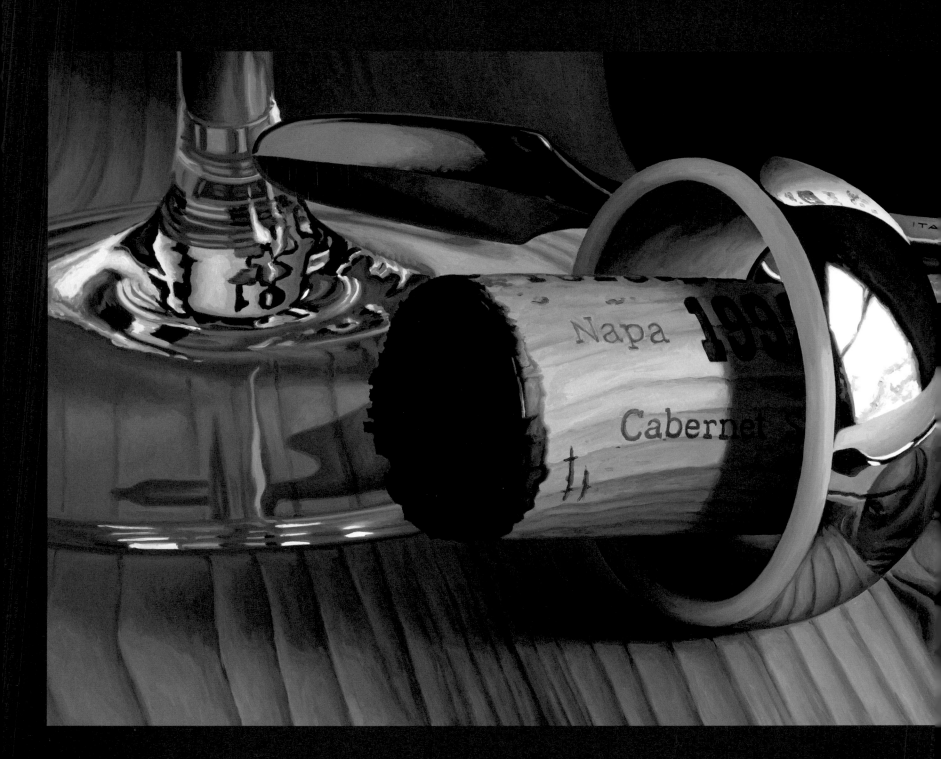

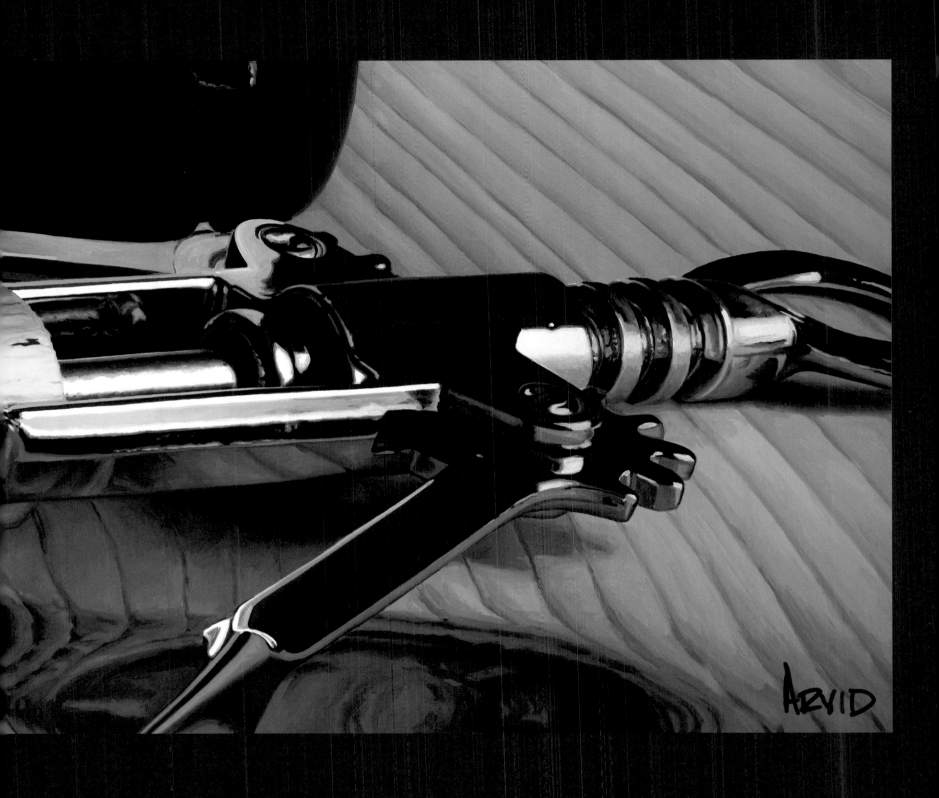

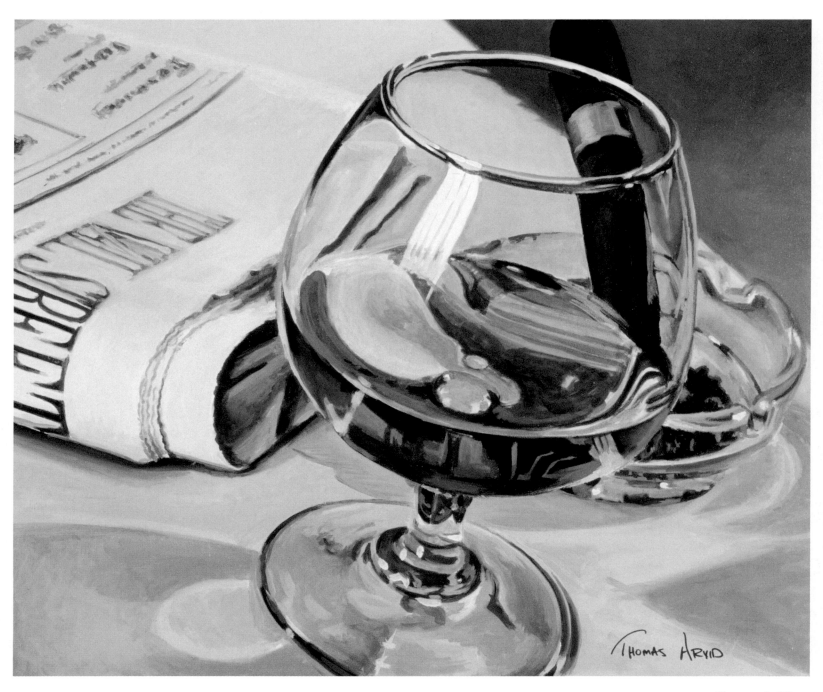

Cognac & Cigar

I got a call one afternoon from a friend and fellow artist, Cliff Bailey. He had been having a drink at a swanky hotel in New York City, and saw "Cognac & Cigar" hanging over the bar. It was a very early piece of mine, and how it got from Atlanta to Manhattan I'll never know. I guess it just goes to show that as an artist, you never know where you're going to find a little piece of yourself.

ARVID

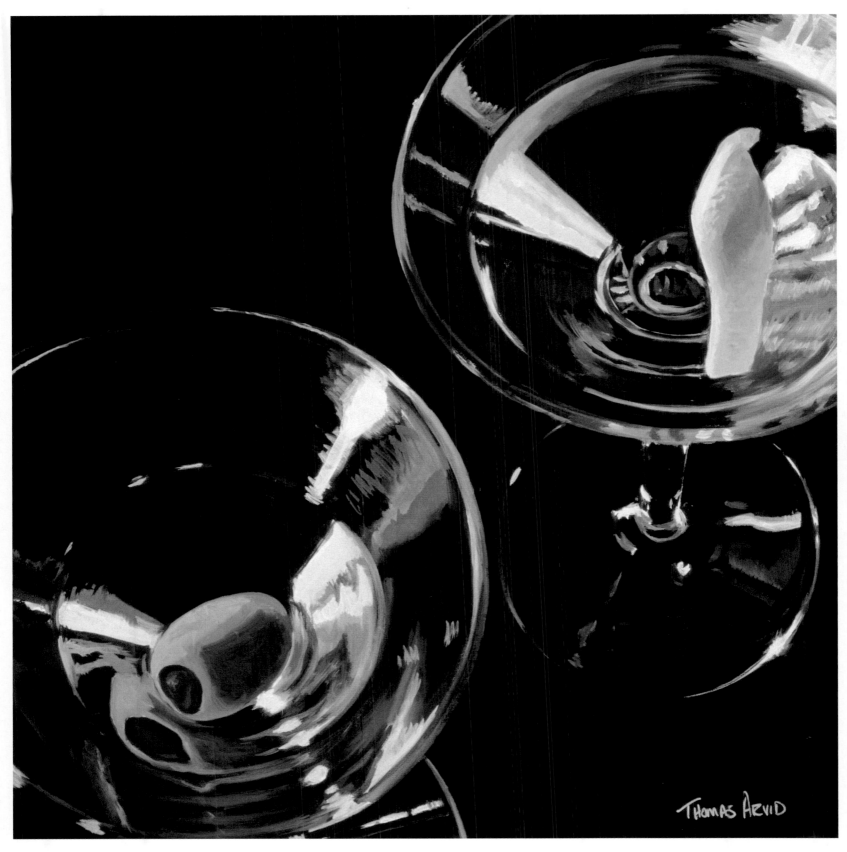

Meet Me for a Martini

Thomas Arvid's style is realism as the sum of many parts. He realistically portrays his subject—wine, bottles— and brings it right into the present, into the moment. He leads you simply, straightforwardly, into a very complex subject. When you study his work, you see what appears to be visually simple and immediate, but that which draws you instantly into his paintings is not simple at all. It is as complex, detailed and fine-tuned as its subject—wine.

—*Dan Giannini*
Collector

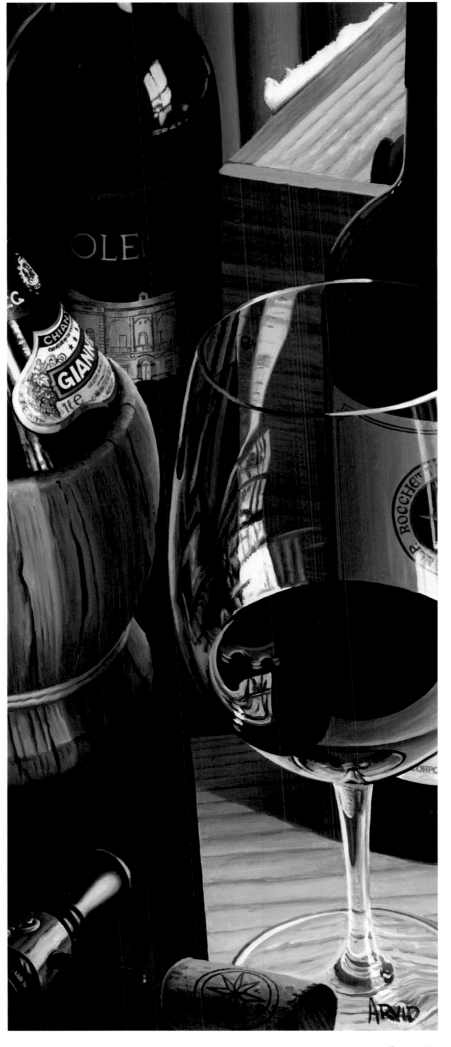

Sassicaia

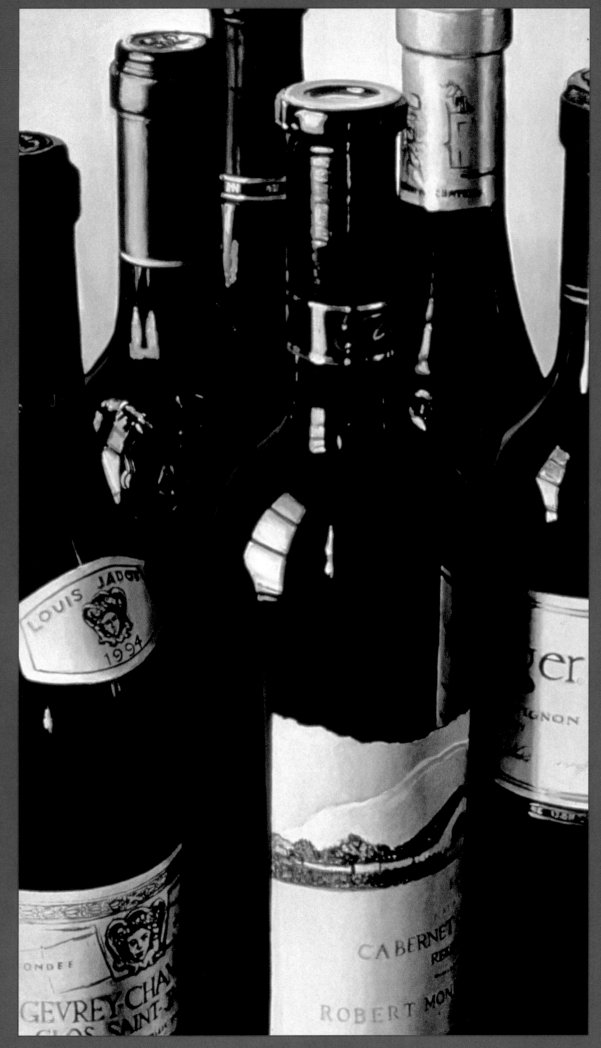

Collection

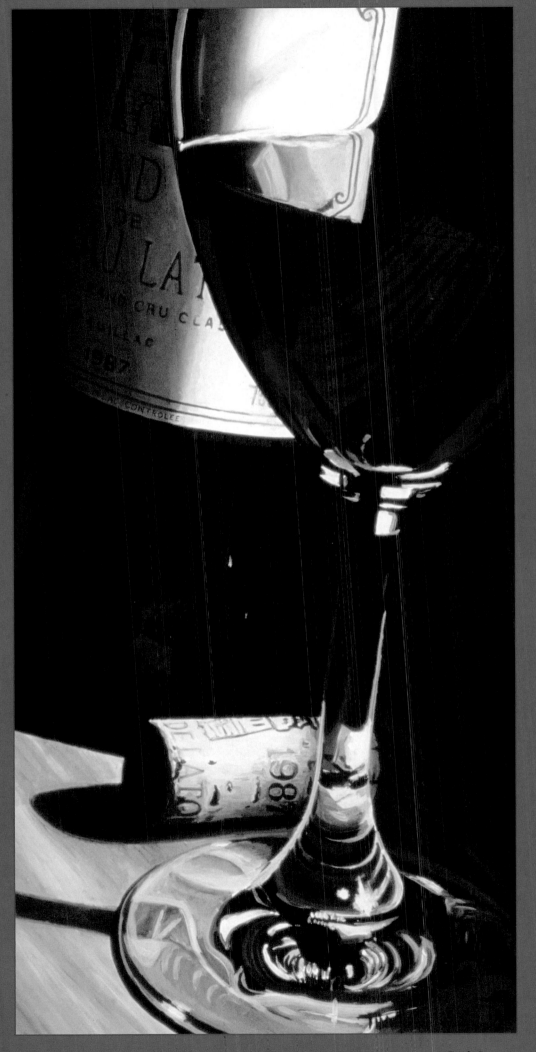

Rich Latour

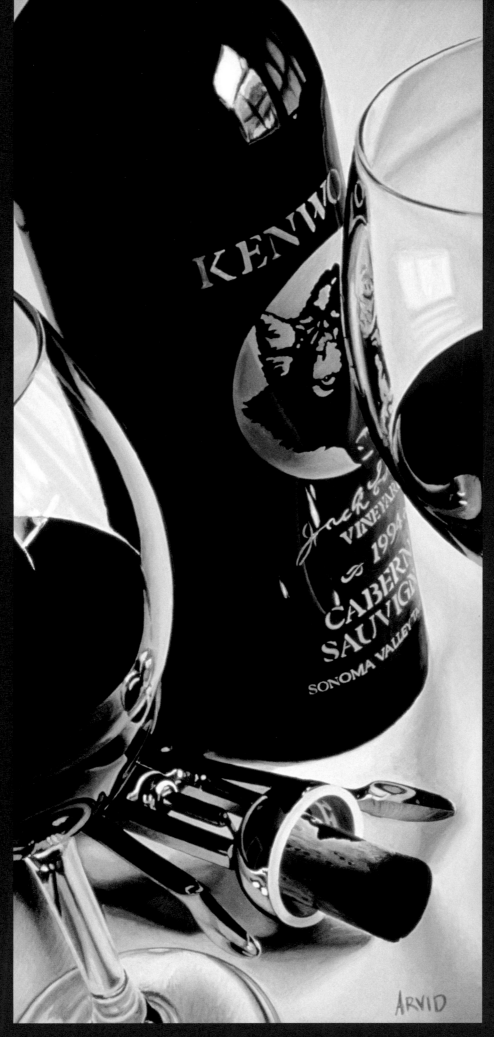

Jack's Cab

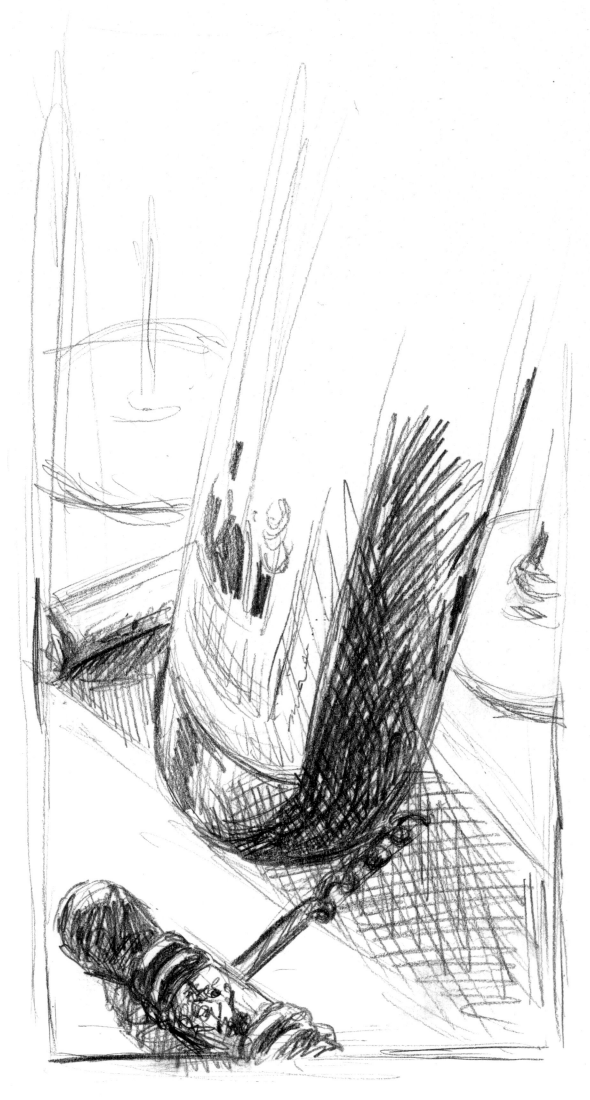

Thomas Arvid has managed to capture on canvas the passion and connection that I feel to my wines. Every time I look at his rendition it's like peering beyond the glass bottle into the very soul of the wine itself. I see clearly the angst and sweat and the anticipation of the day those sweet berries were harvested. It brings the evolution of the wine back in a clarion way.

—*Joe Davis*
Owner, winegrower
Arcadian

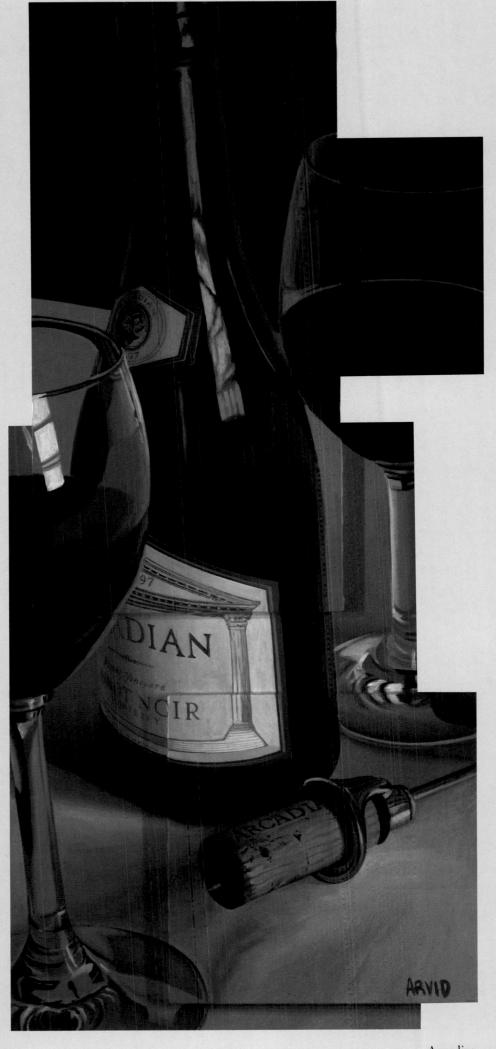

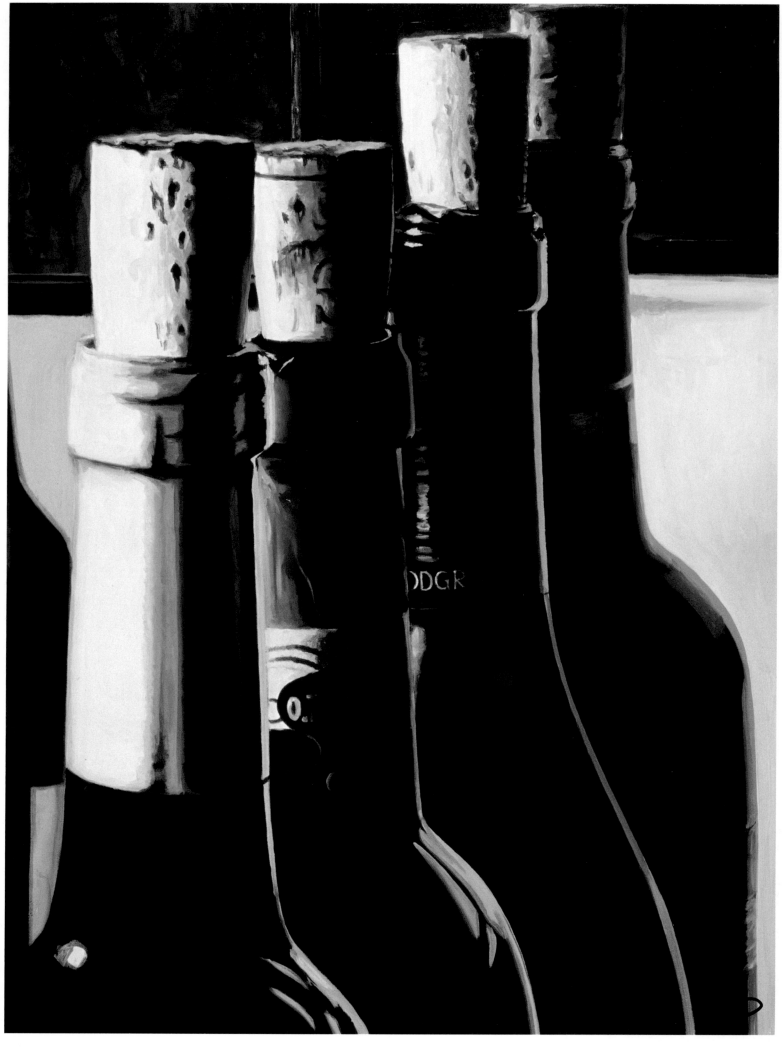

All in a Row

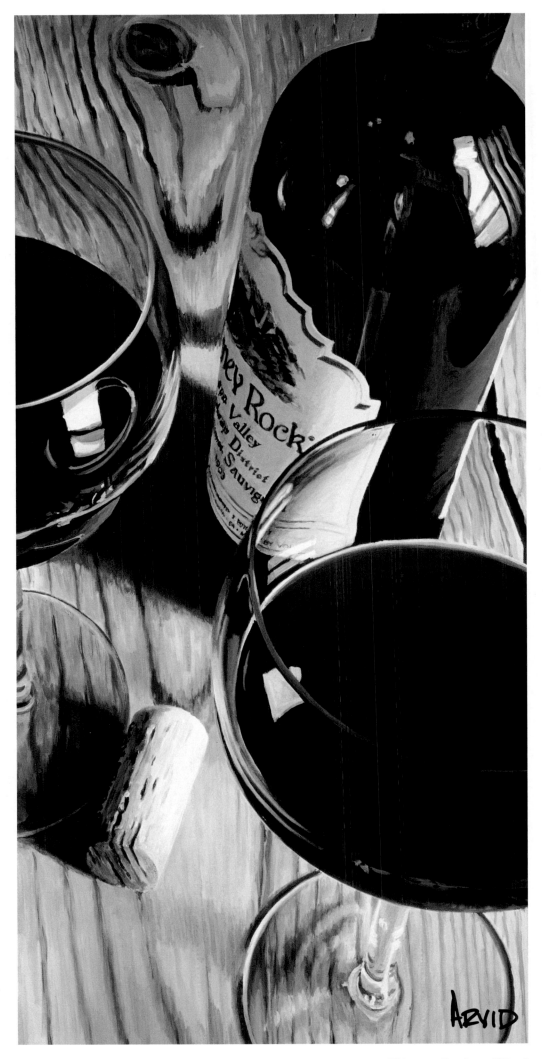

Chimney Rock on Wood 45

These are some of my first paintings. I wasn't yet painting wine. I was just starting to experiment with photorealism and the steps involved in turning a photograph into a painting. I didn't even have a camera yet. Vanessa (my model, and then my wife) and I had to go to a friend's house to take the picture from which I painted. Even then, I was trying to intrigue the viewer with what you can't see in the painting.

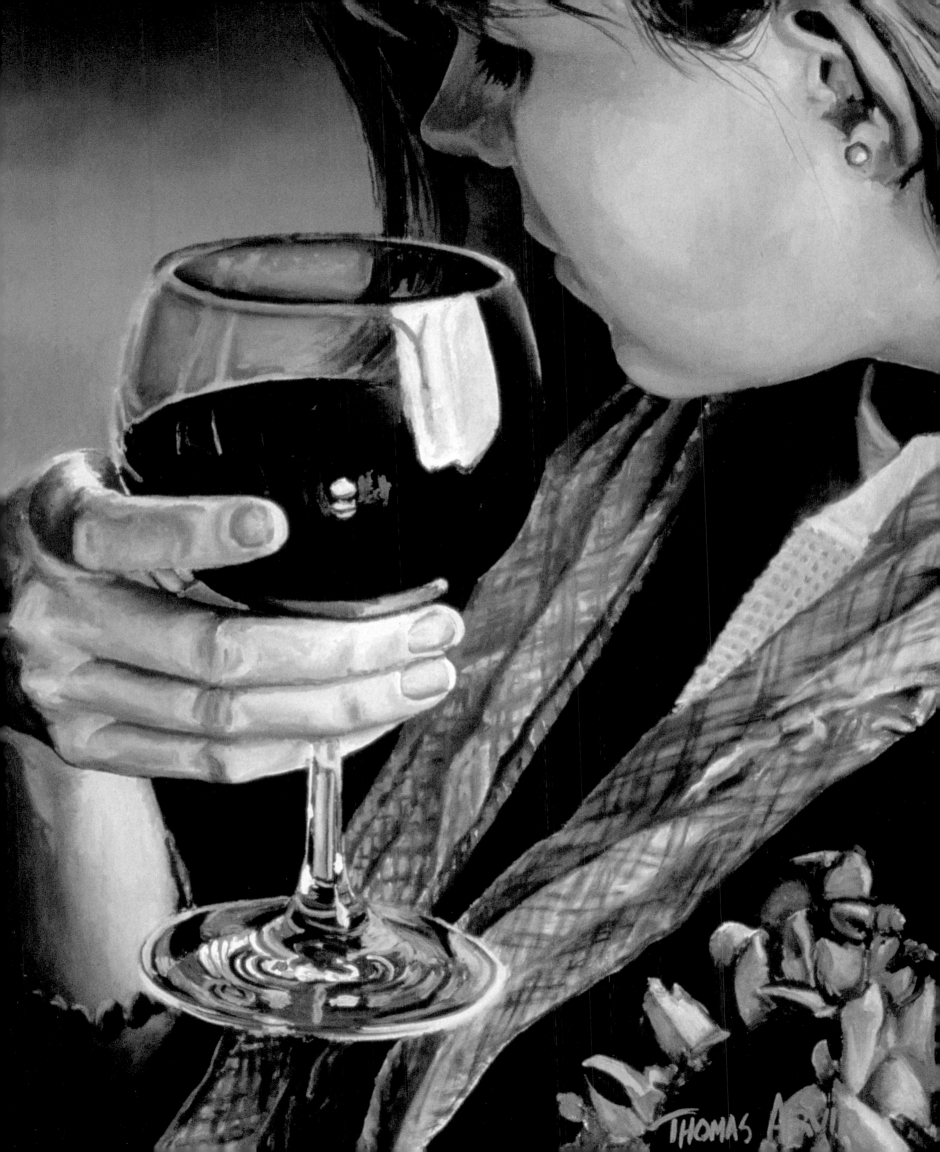

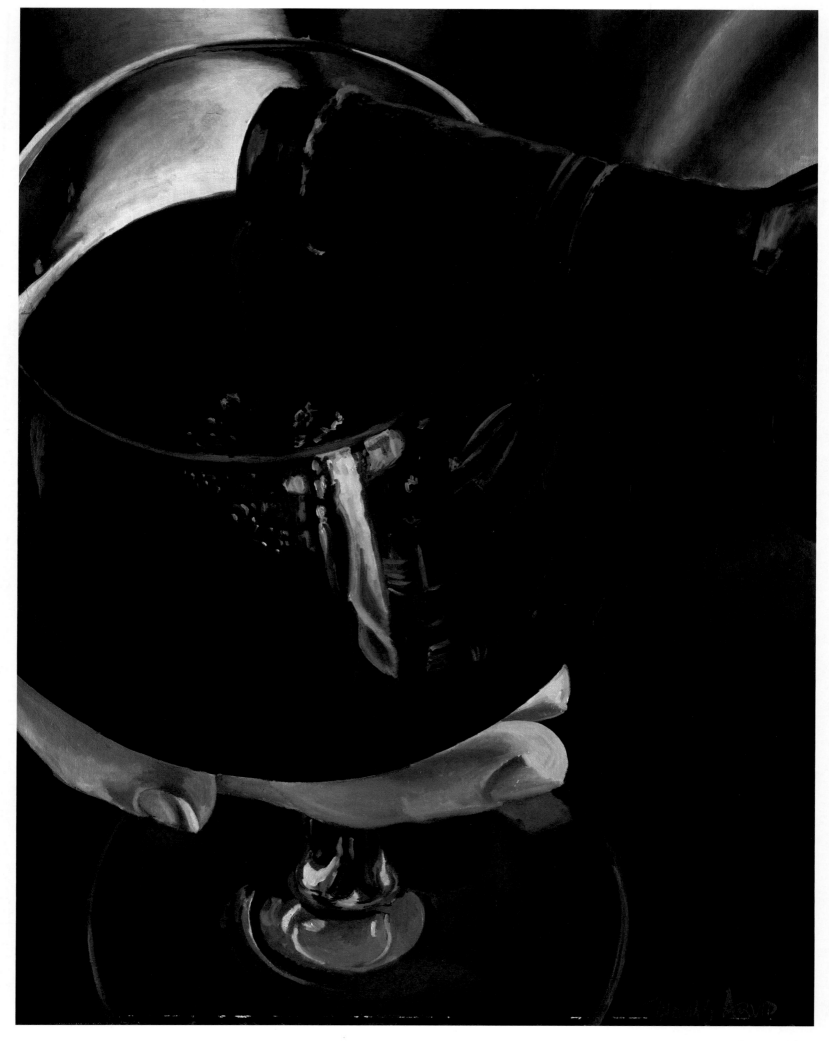

Wine in Glass

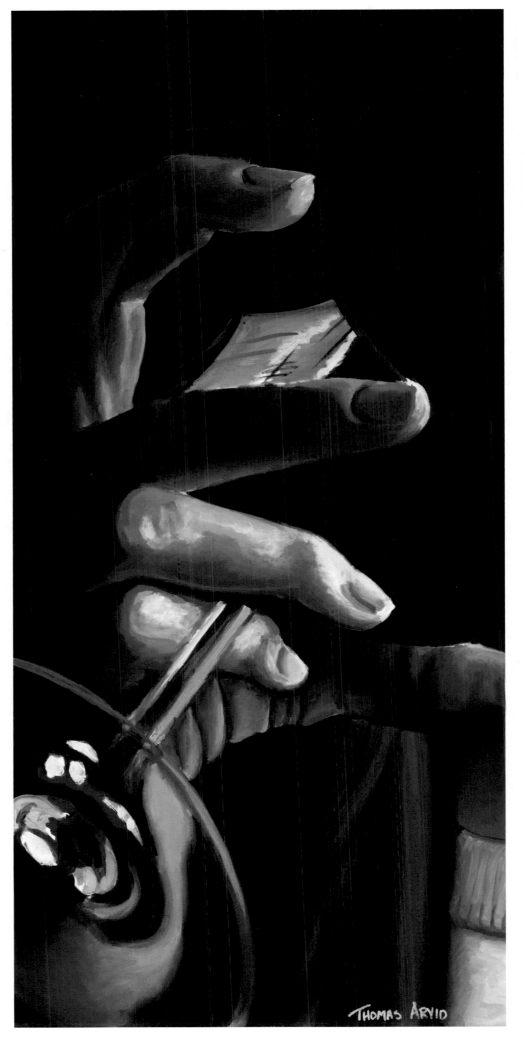

Sip

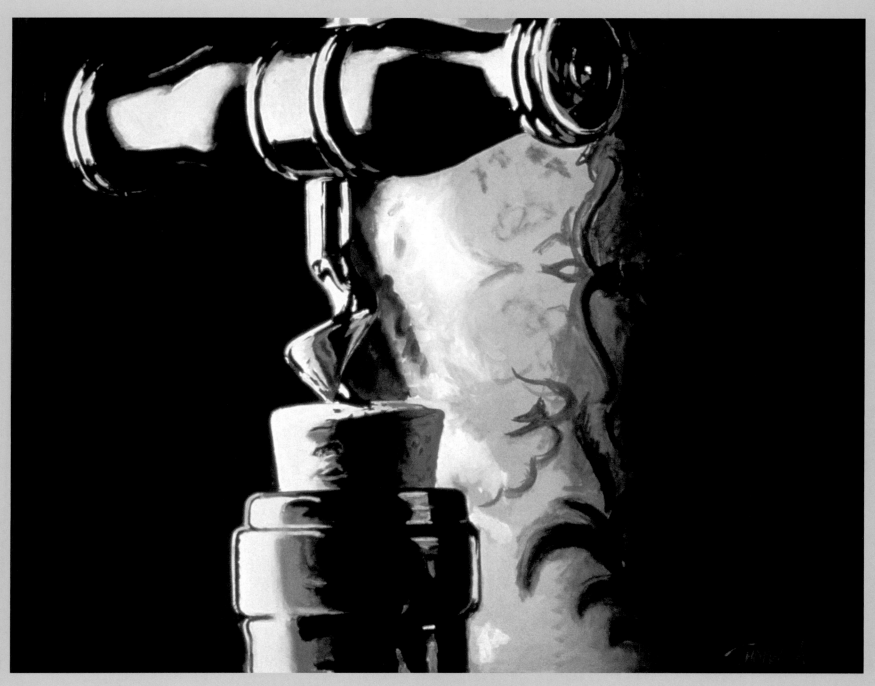

Title Unknown

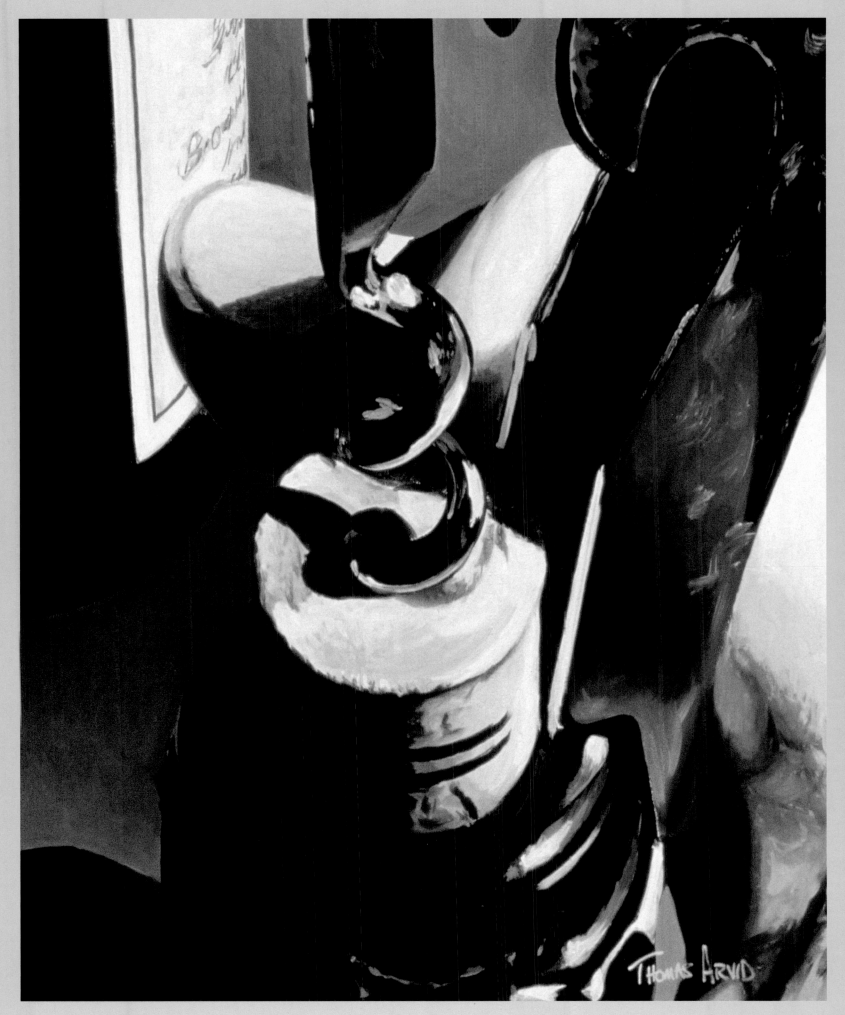

Corkscrewed

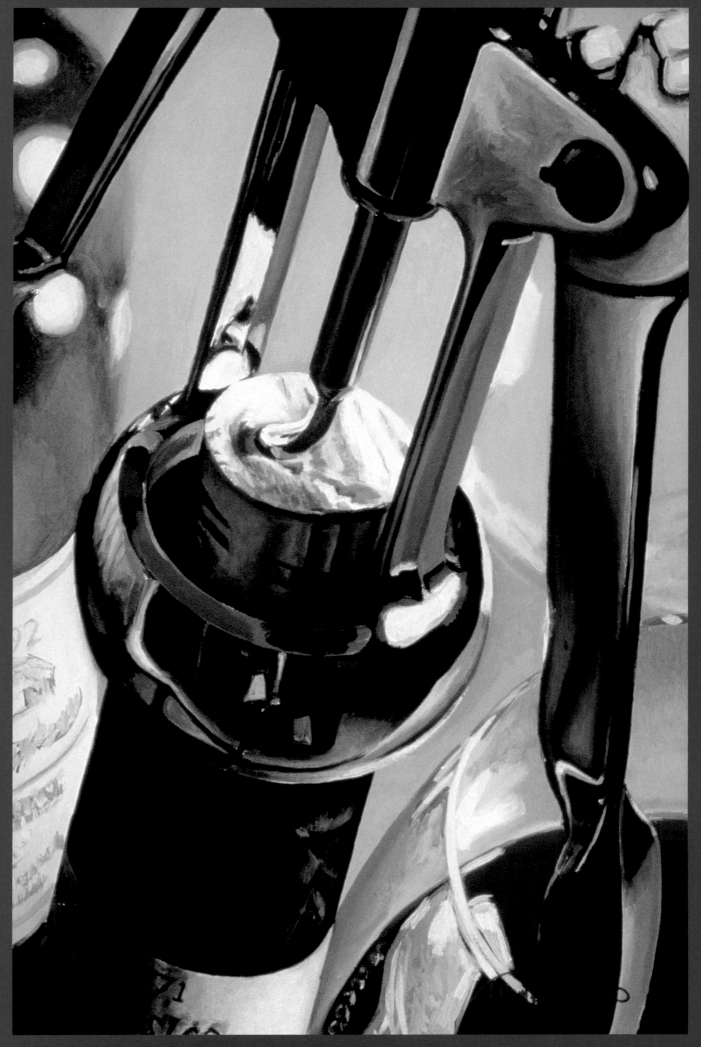

Corkscrew

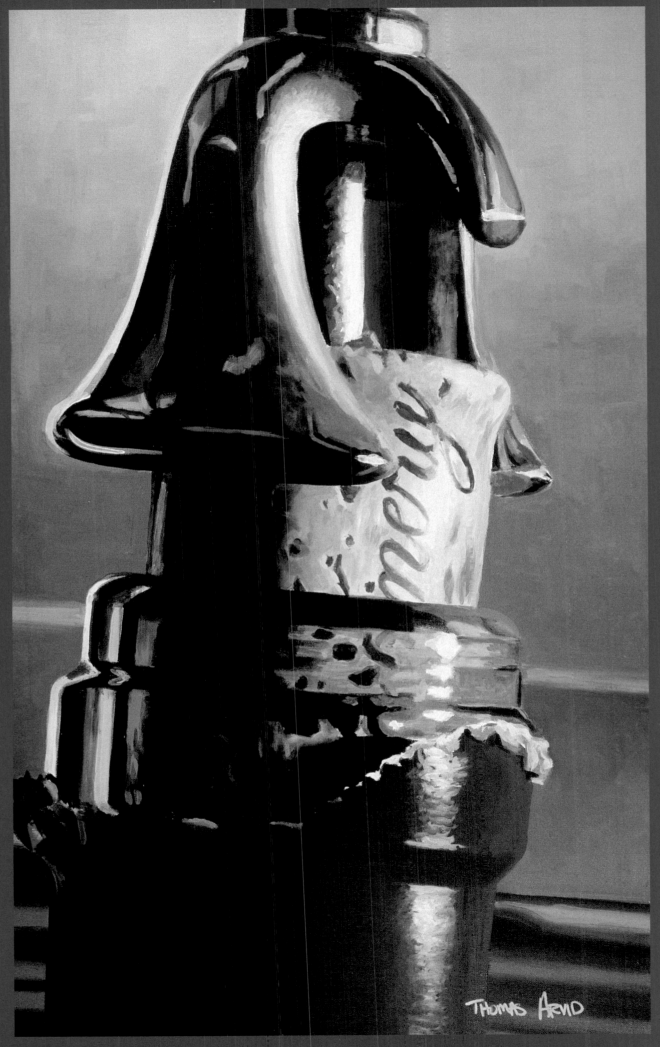

Metal Corkscrew 53

This is one of my favorite pieces because of the time in my life it evokes. My wife and I had recently purchased our first home—a 1950's bungalow—and this blue wallpaper was hanging in the kitchen (from 1950 we suspect!). Vanessa detested the wallpaper, but I really liked it for the background of my paintings. The color is such a great contrast to red wine. Now when I see this piece I remember that time so well: we were so crowded in this little house, and we used the tiny dining room as an office and a studio. We were falling all over each other, trying to create art, run a business and raise a family in 900 square feet—but we were having such a great time.

ARVID

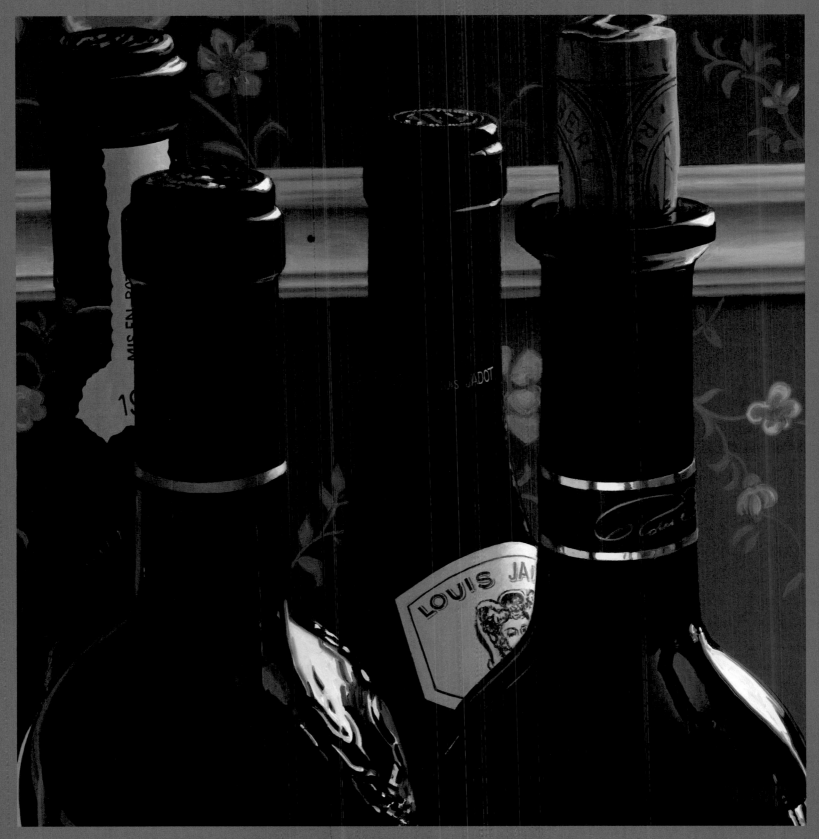

Four in the Kitchen

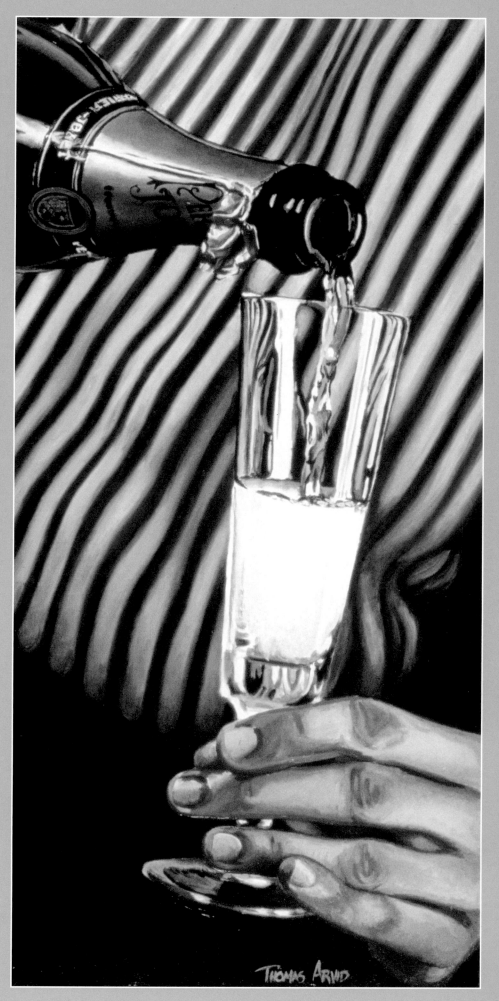

Champagne Pouring

othing like finishing an incredibly detailed painting only to have someone say, "It is beautiful Thomas, but doesn't California have an 'R'?" I guess all those years I spent painting signs didn't do anything for my spelling . . .

ARVID

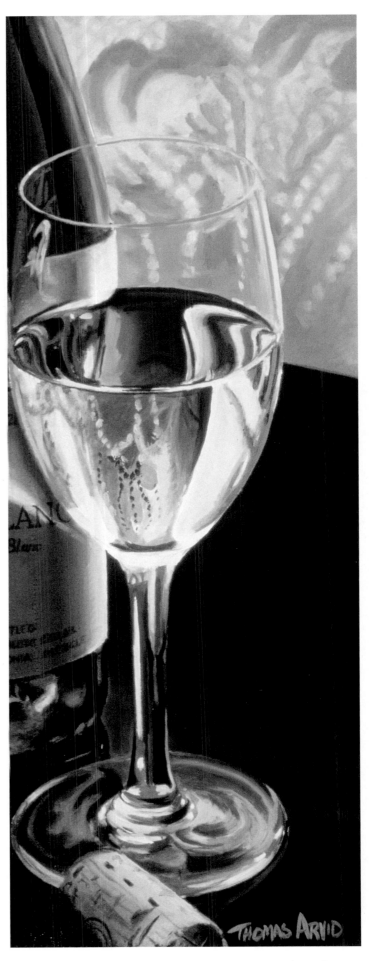

Title Unknown

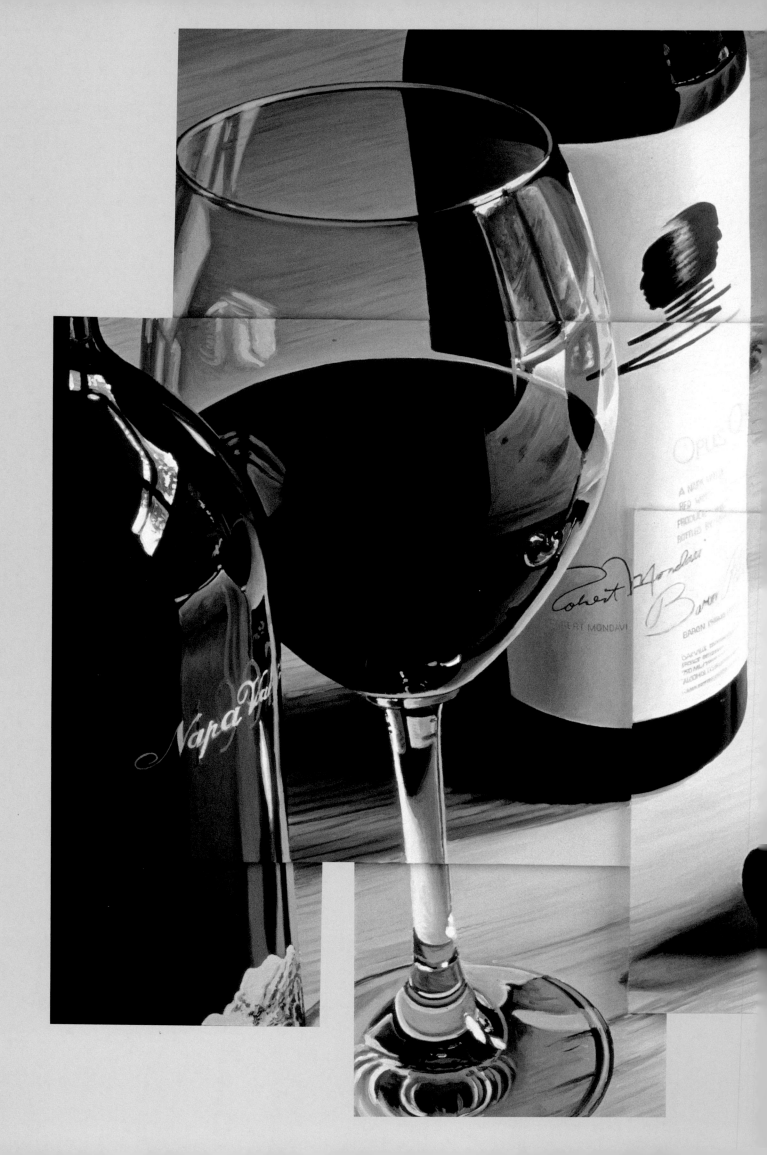

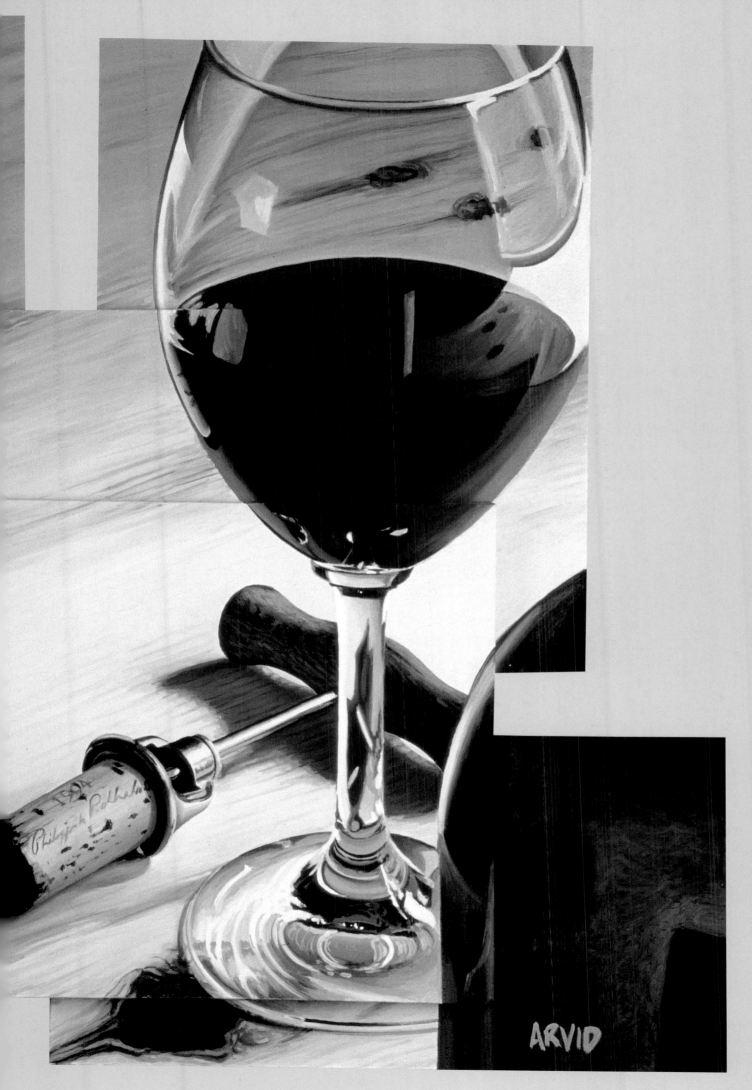

ARVID

Opus Collage

Sketches are a playground for me, a chance to do something quick and fun. My paintings take a long time, not just because of the extreme detail in which I work, but because of the medium itself. One of the best feelings an artist has is creating something from nothing, and sketches, whether they're pencil, charcoal or oil, allow me to create something in a short amount of time. It's instant gratification.

My sketches usually end up on someone's wall, but in the beginning they are for no one in particular. I make them as rough or polished as I want; they're for me alone. I would rather be painting than anything else, but when I'm out of the studio, sketching gives me the opportunity to stay focused on my work. I love to sketch; when I'm flying on an airplane, riding in a car, or sitting on the beach, it allows me to constantly create.

ARVID

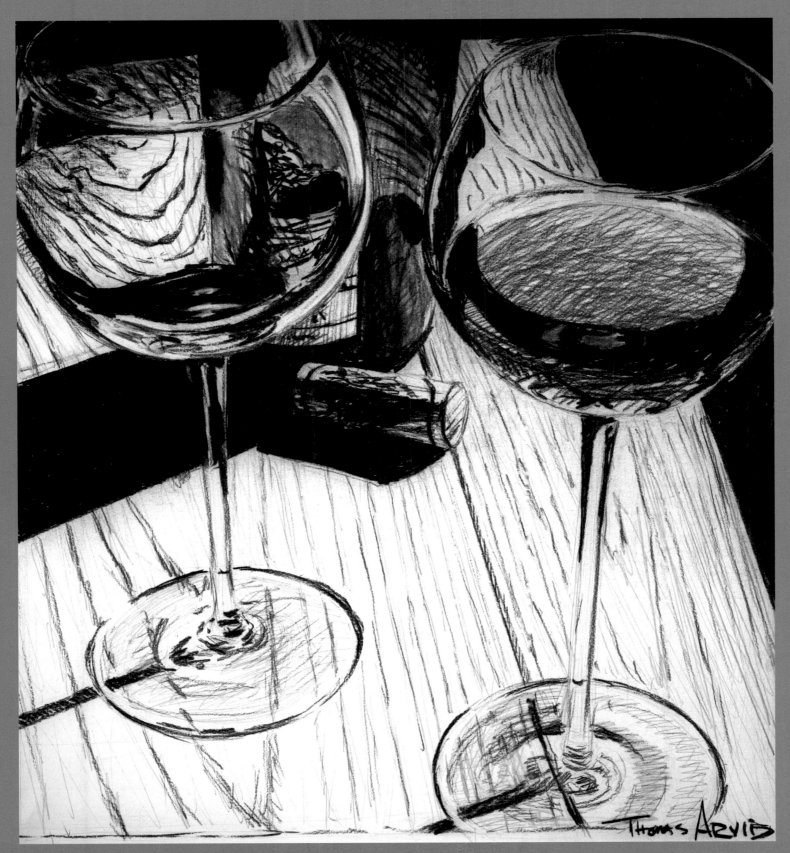

Touch of Silver - Charcoal

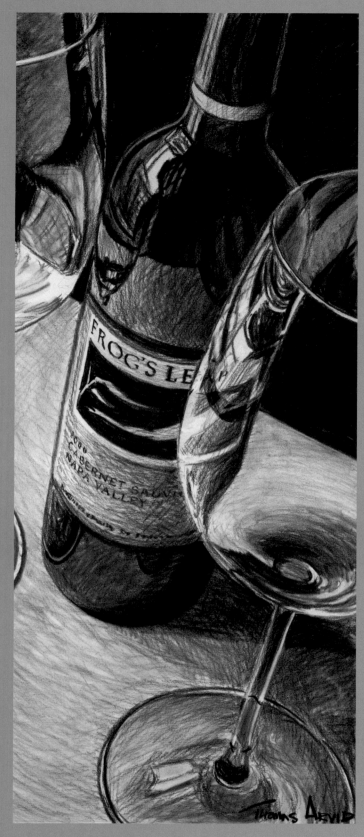

Look Before You Leap - Pencil sketch

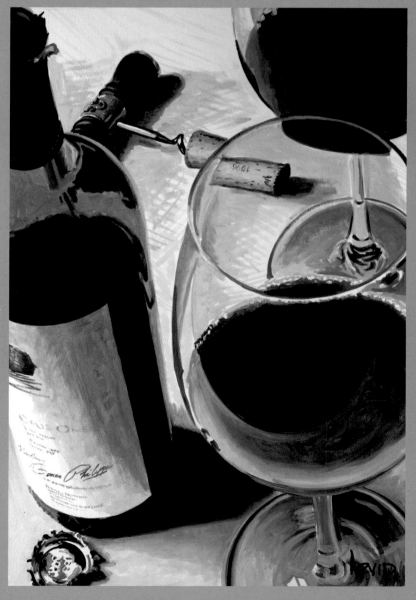

Elements - Oil sketch

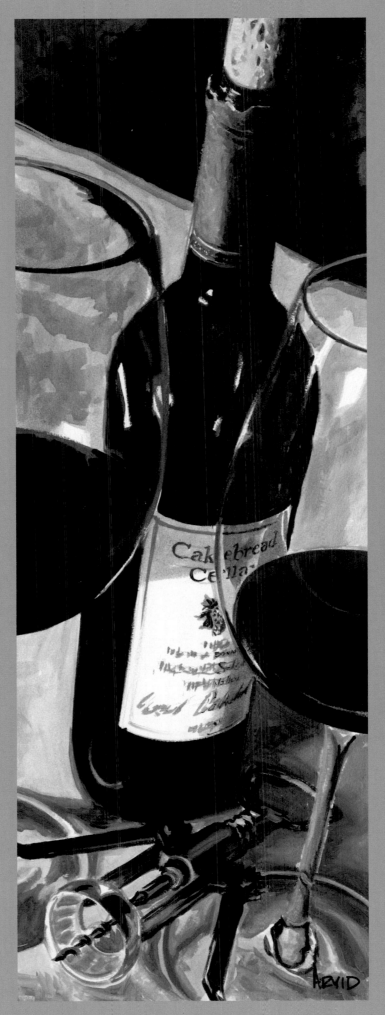

And Drink It Too - Oil sketch

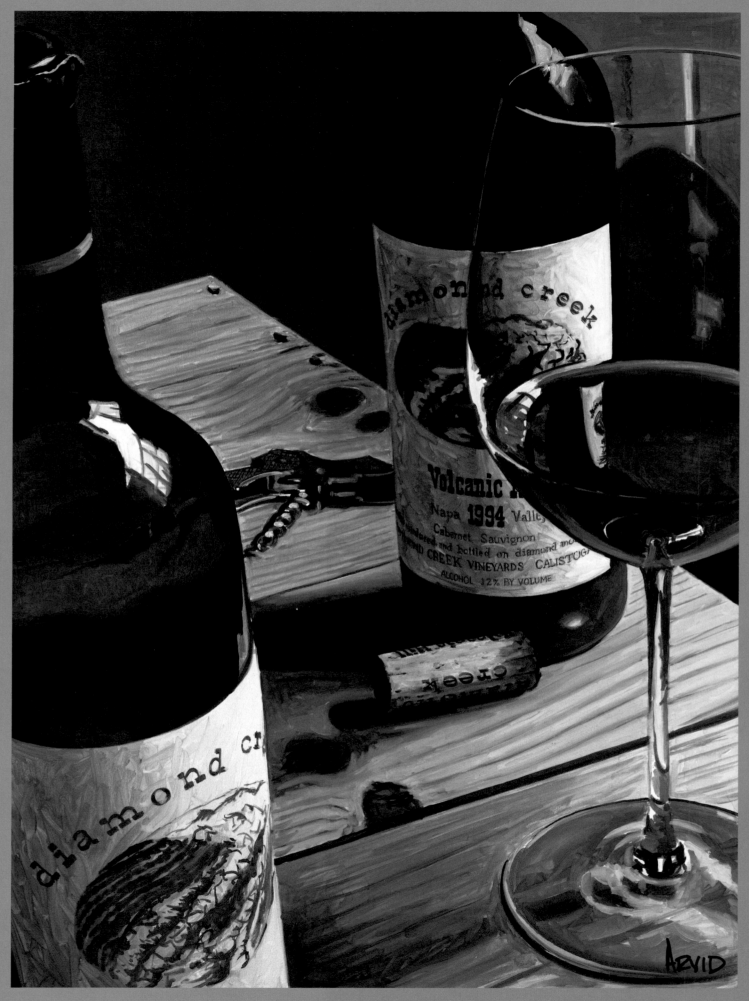

Diamonds in the Rough - Oil sketch

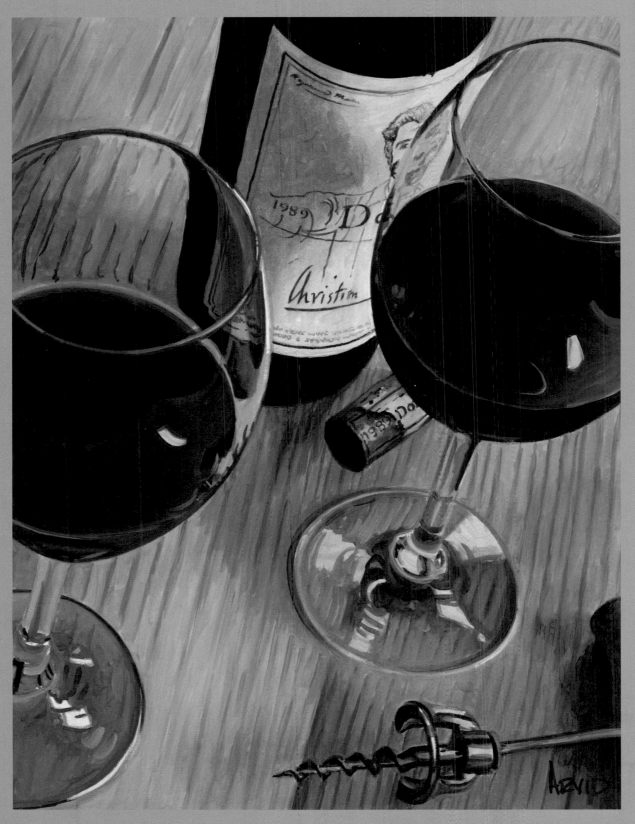

Worth Its Wait - Oil sketch

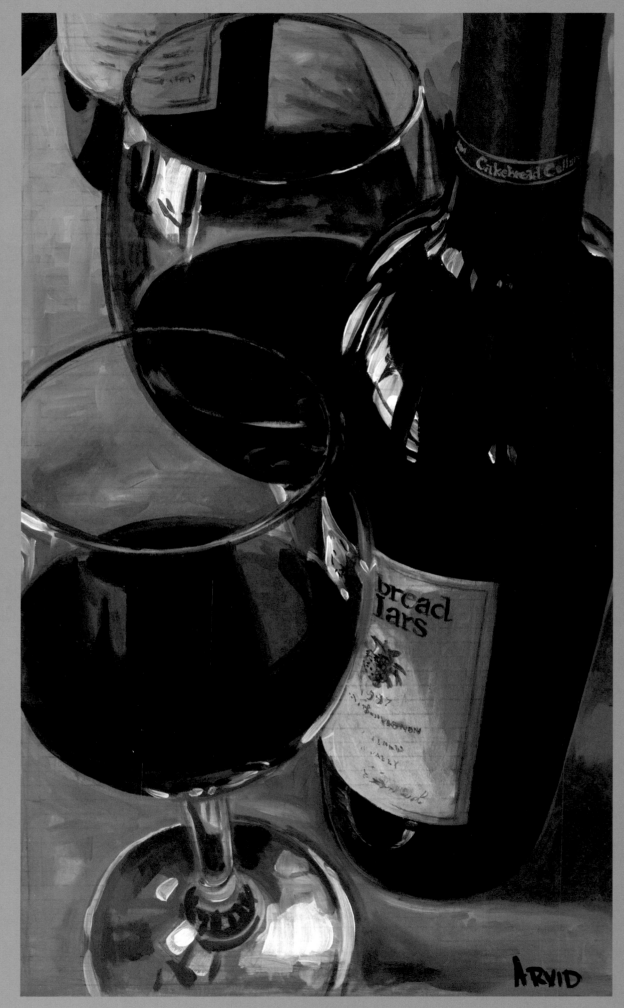

Cardboard #1 - Oil sketch

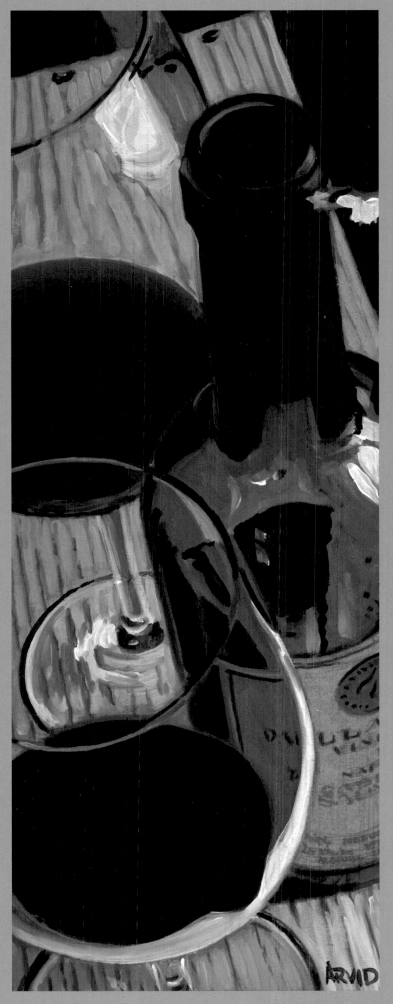

Cardboard #2 - Oil sketch

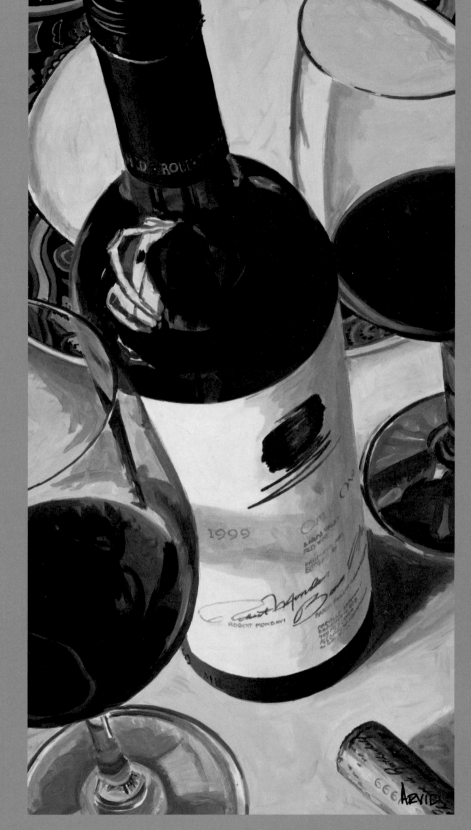

Life of the Party

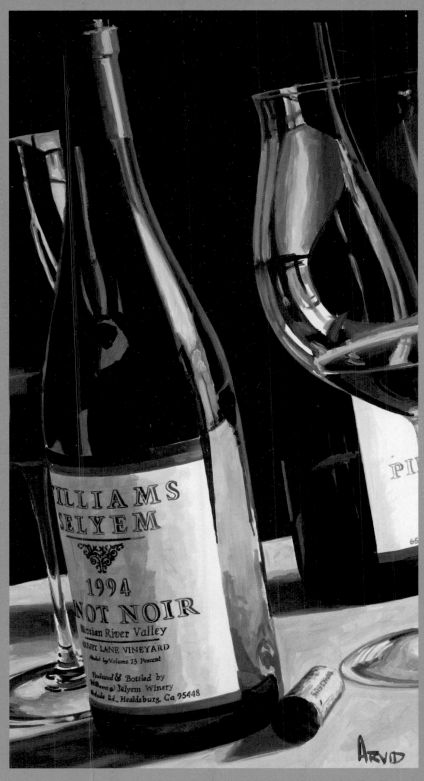

So Deserving

I'm always looking for the next best thing, looking to see what can change the way we do things. Creating a serigraph was an opportunity to create something new and merge several creative processes and people. Serigraphers are artists—they duplicate the process of building up oil paint by using multiple screens—really exploring the art of texture. It almost makes the finished serigraph a piece of sculpture. I worked with the serigrapher to enhance the films that are then burned to make screens, so it is actually my brushstrokes that you see in the finished piece. This kind of partnership creates a whole new level of fine art.

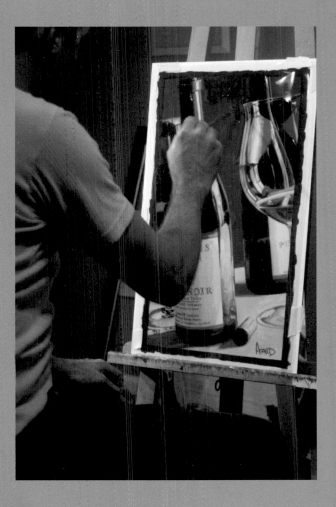

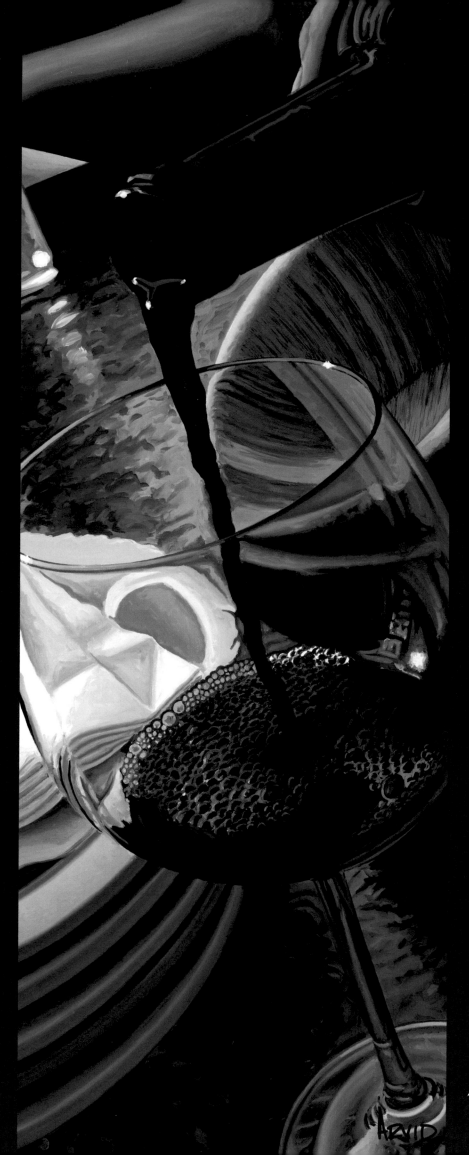

The Pour

People always tell me about times when they're at their house, sitting around and drinking wine, and they start arranging impromptu "Arvids" with the glasses, bottles and corkscrews on the table. It's fun to do, shift a glass here, move a cork there, and then someone says, "Oh look, it's an Arvid!"

"The Pour" was an impromptu Arvid. I was sitting out on the deck of a friend's house, enjoying wine with my wife and friends, and I looked around and saw a true Arvid in the moment. The composition was there, and the light was beautiful, but more than anything I was feeling just what I want viewers to feel when they experience a painting, or when they are drinking wine.

Wine is meant to be poured, meant to be shared, meant to be part of the experience of getting together with friends and family. "The Pour" isolates a moment of anticipation; you can hear the wine being poured into the glass, the food is on its way out, conversations are starting up, and you know it's going to be a great night.

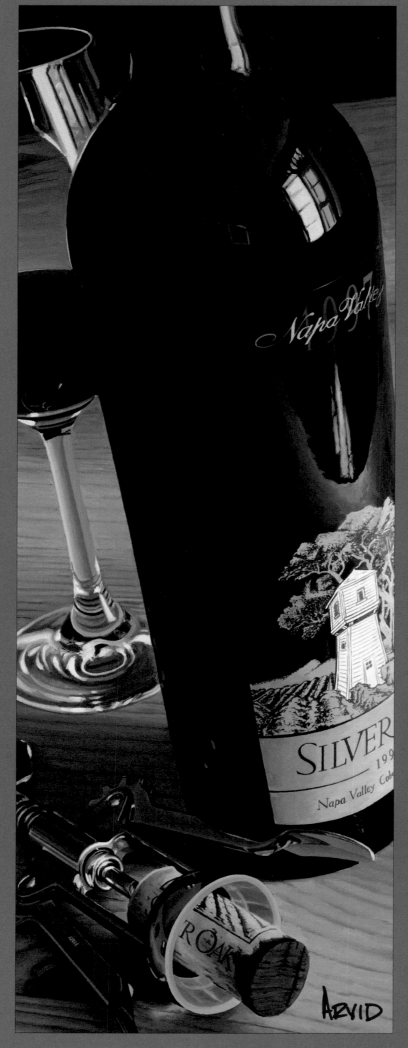

Party of One

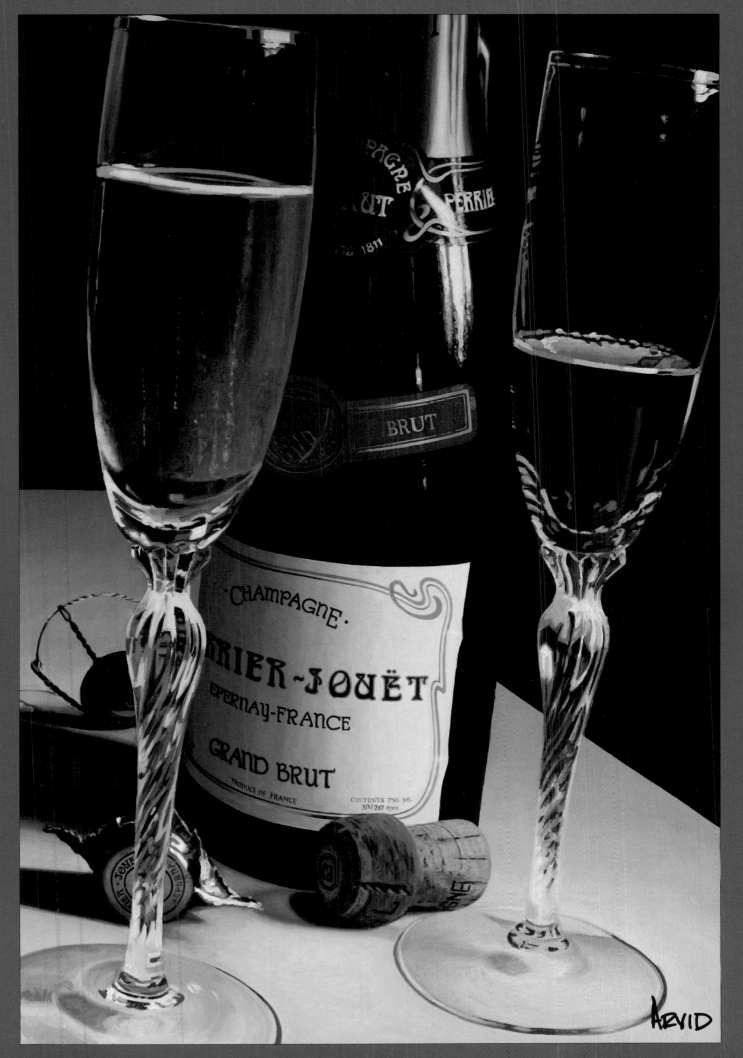

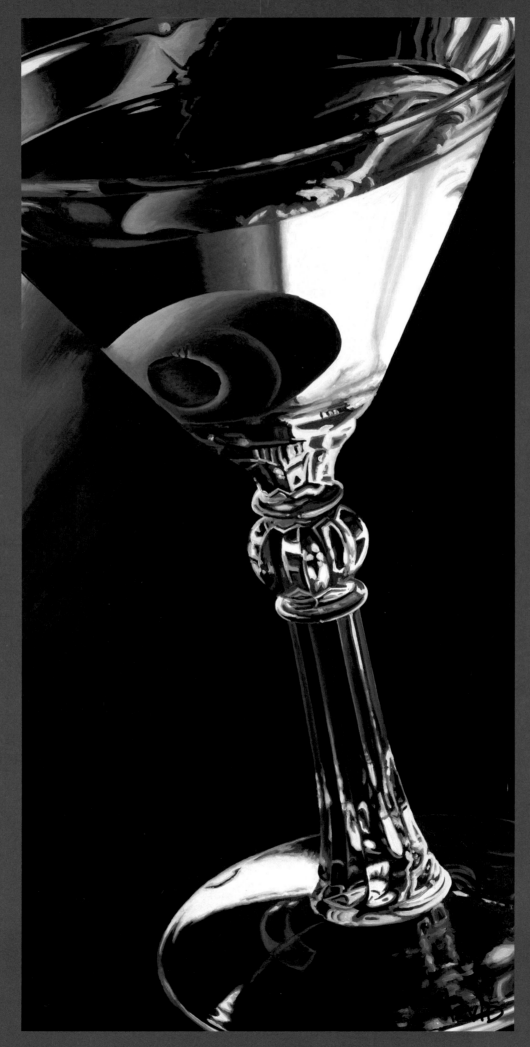

Classic Martini

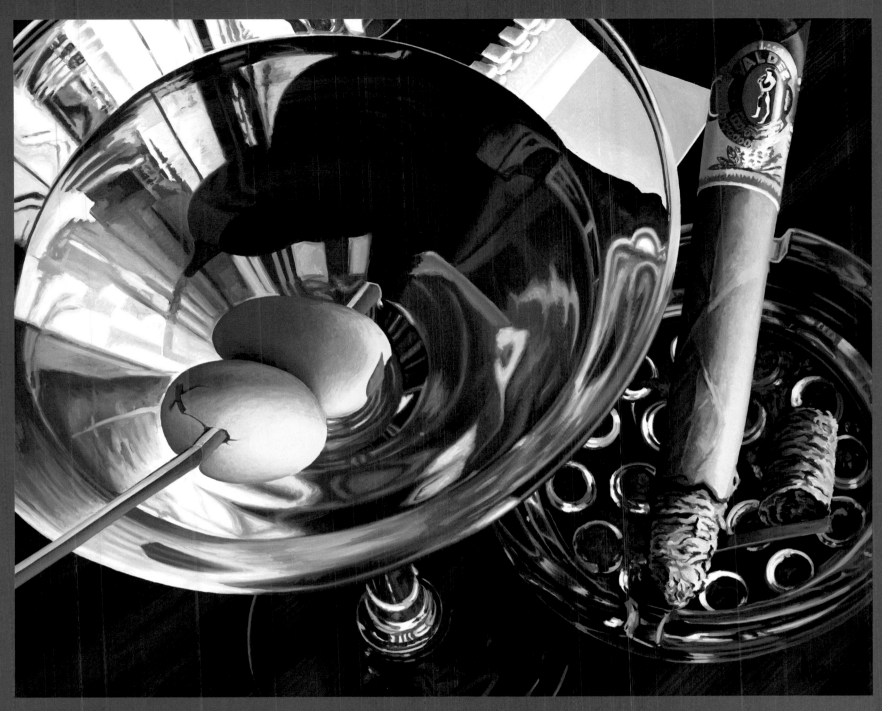

Martini-Cigar

With my paintings, there is never a complete subject: everything is interrupted. I show fragments of things and your mind creates the rest of the image. I think that a lot of the strength of my work lies in that idea. People become connected to a piece that lets them create the area around it. Wine is a great subject to do this with because it is familiar. You know it, so your mind fills in the composition with your own experience. It becomes the viewer's painting too.

ARVID

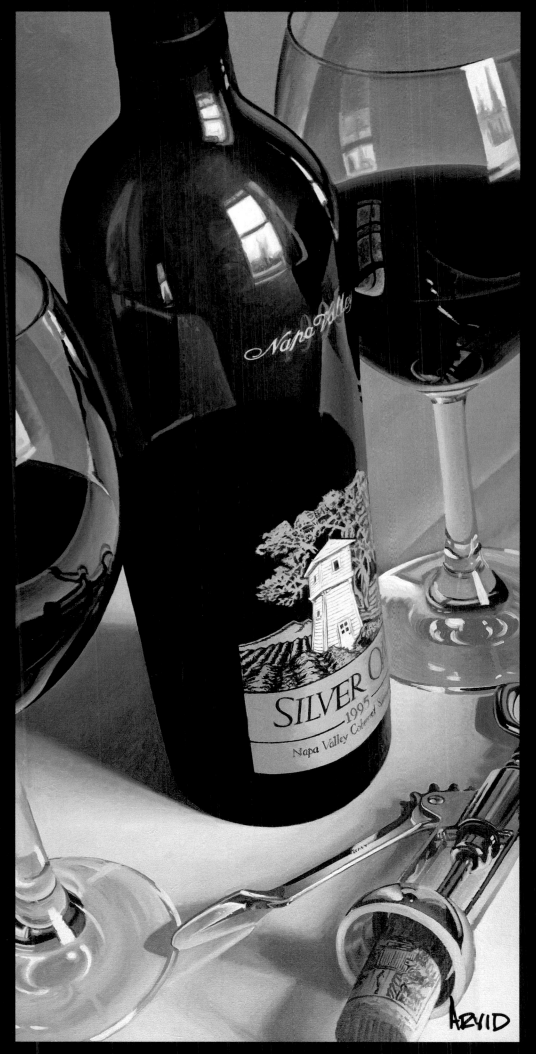

ARVID

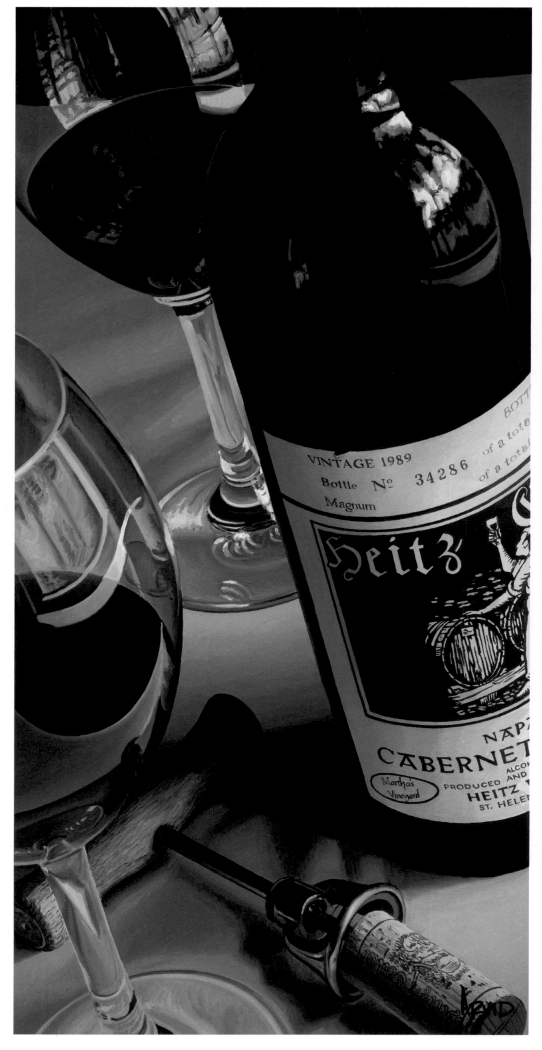

Reaching New Heitz

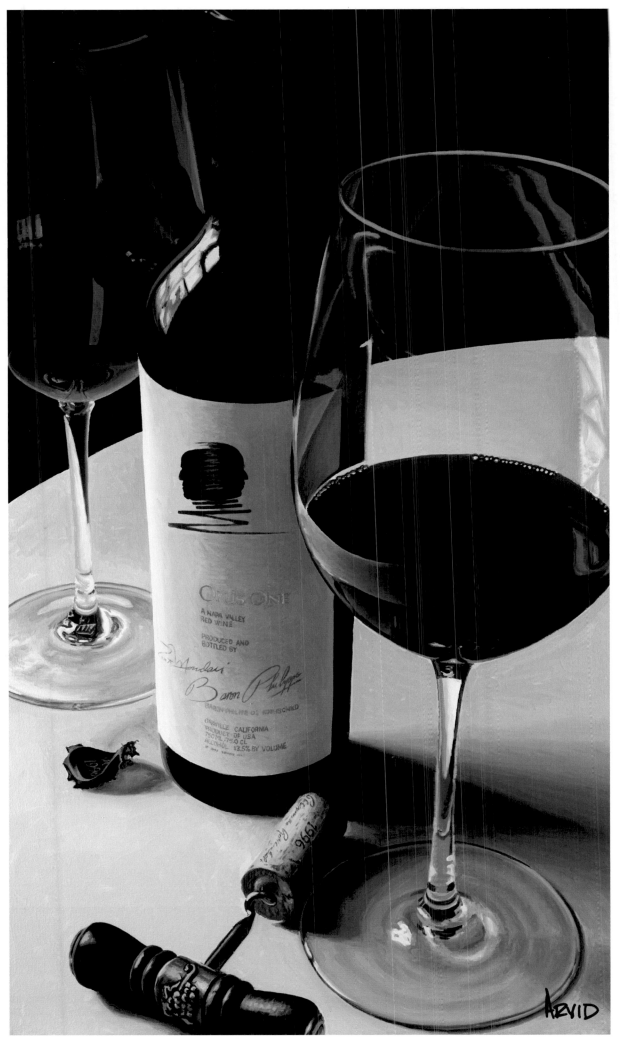

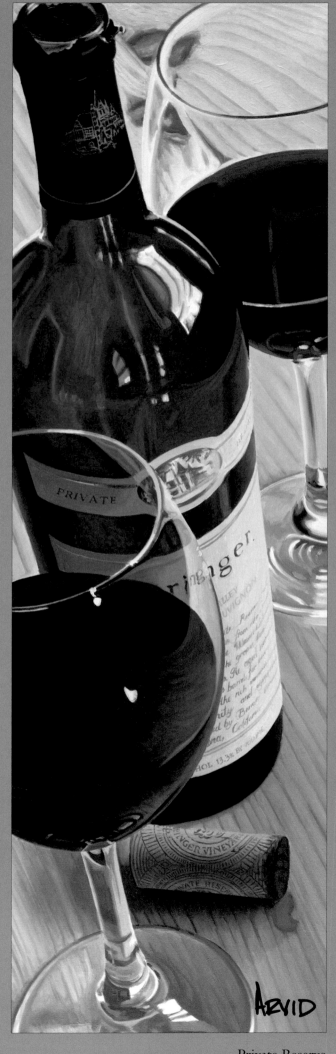

Private Reserve

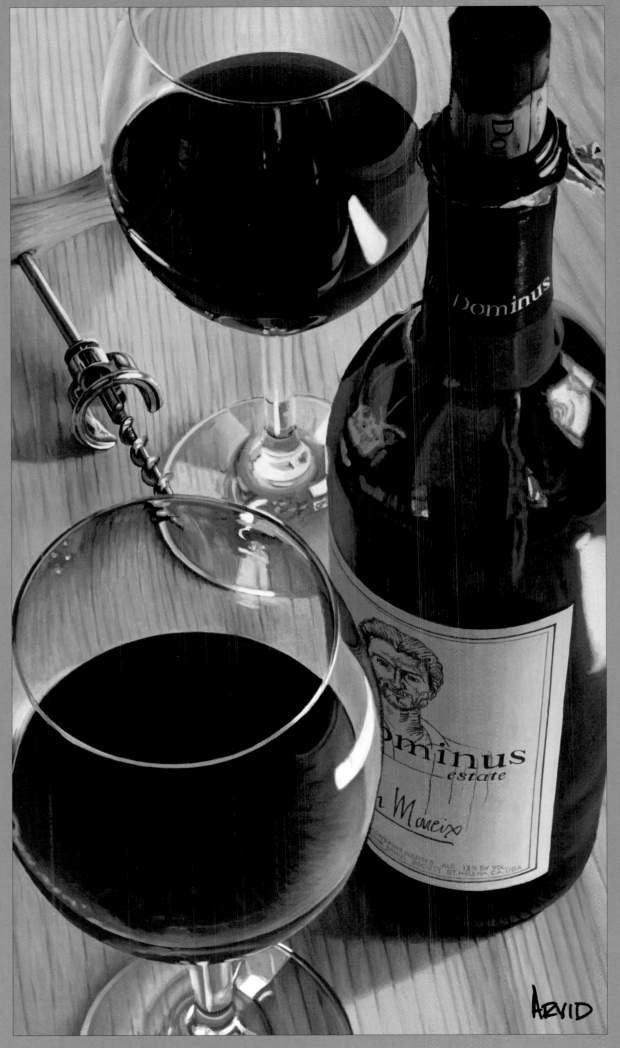

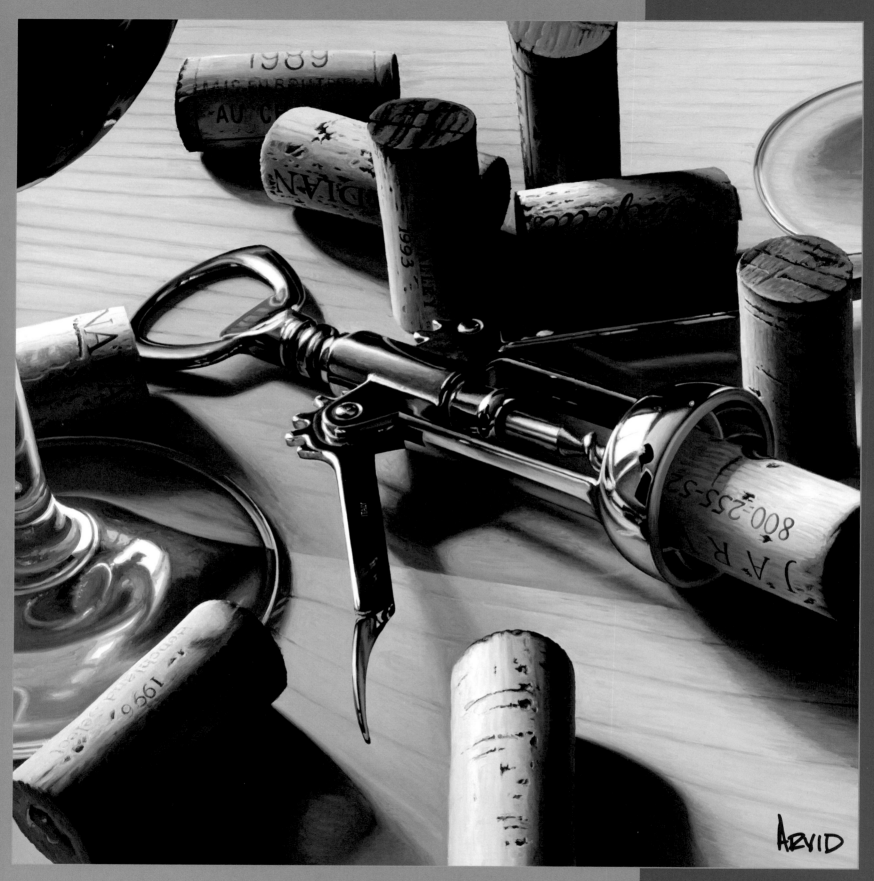

Unplugged

This is one of my favorite pieces. I love the informal balance, how the corks seem randomly scattered but form a perfectly balanced abstract composition. In the same way, the piece seems simple—a repetition of corks—but it is one of my more complex works. Each cork is different, with its own color, placement, stain marks and design.

ARVID

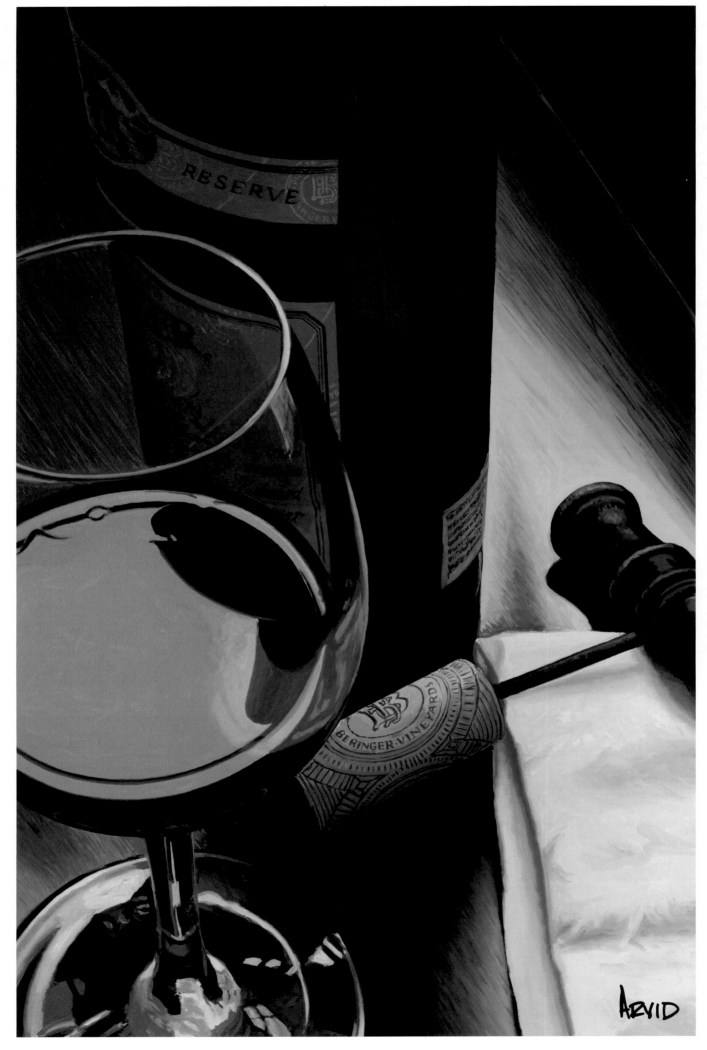

Private Study

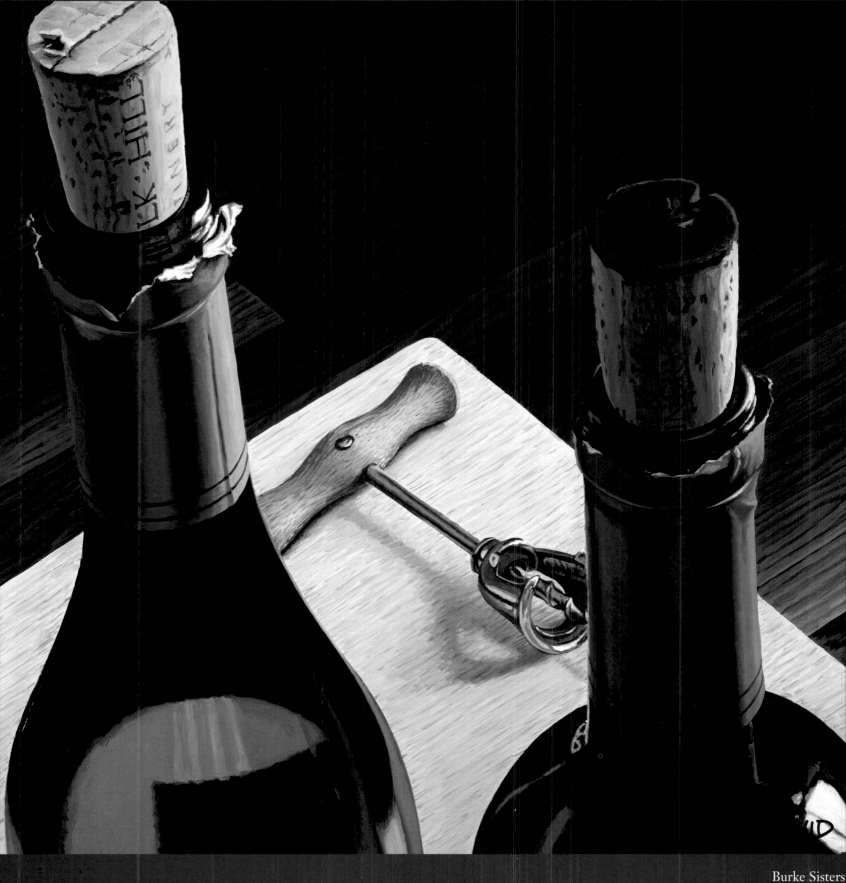

Wine is a great subject to paint because it has so many different elements: hot and cool surfaces, fluid, wood, glass, chrome, cloth. As a painter, it gives me so much to draw from, so many things with which to work and experiment. This piece is a perfect example that combines all of the elements that I like to work with in a painting; it is a composition of textures and materials as well as color and space.

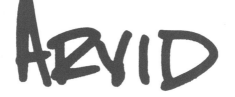

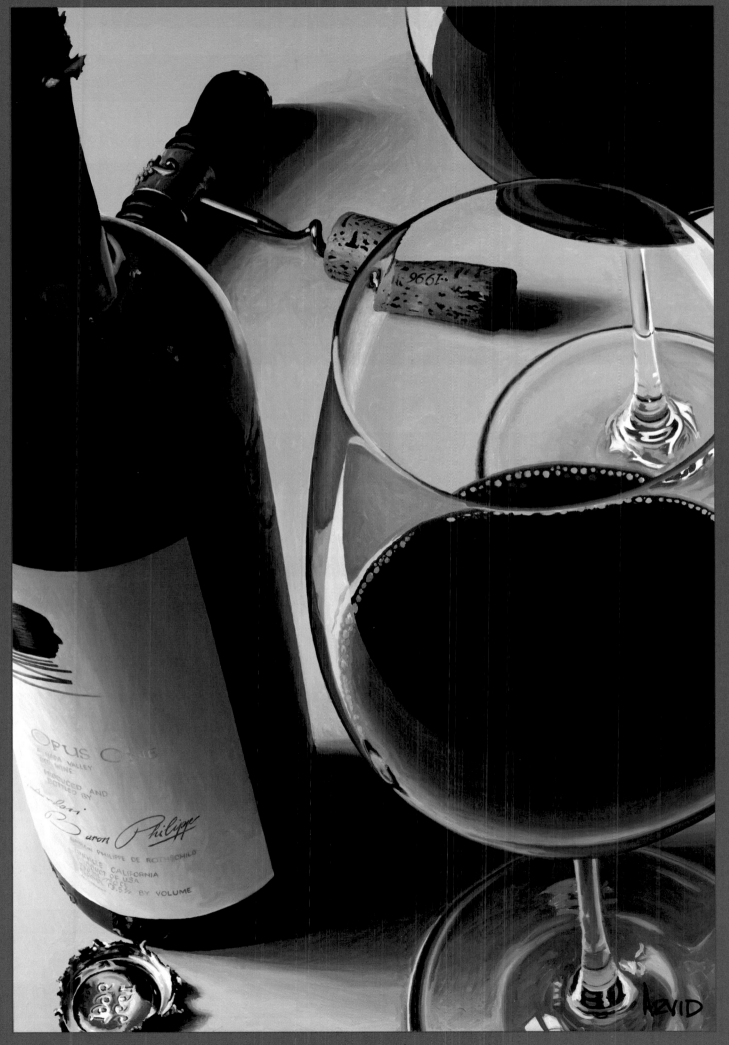

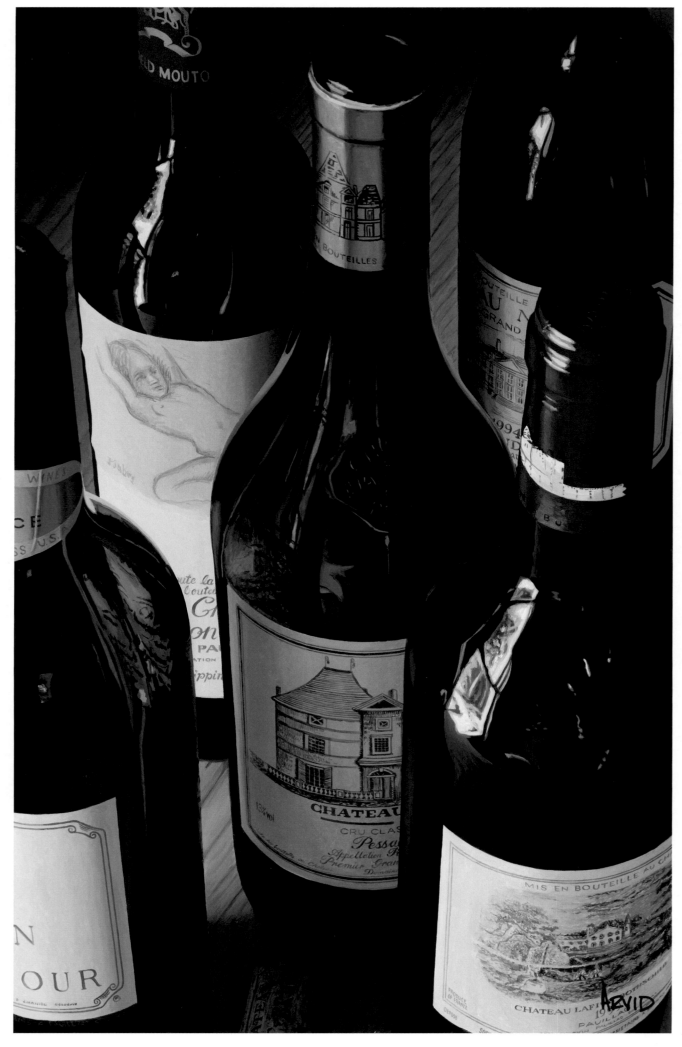

Five First Growths

"Five First Growths" detail

When I started, I didn't know much about wine. I would go to the grocery store, buy some red wine and set up a composition. After seeing my grocery selections, someone said, "Thom, you have to start painting better wines," and he gave me a great bottle of wine. I remember thinking, "Wow! Wine tastes like this?" As most artists tend to paint what they know, this is an amazing facet about painting wine—I'm constantly learning more about what I paint.

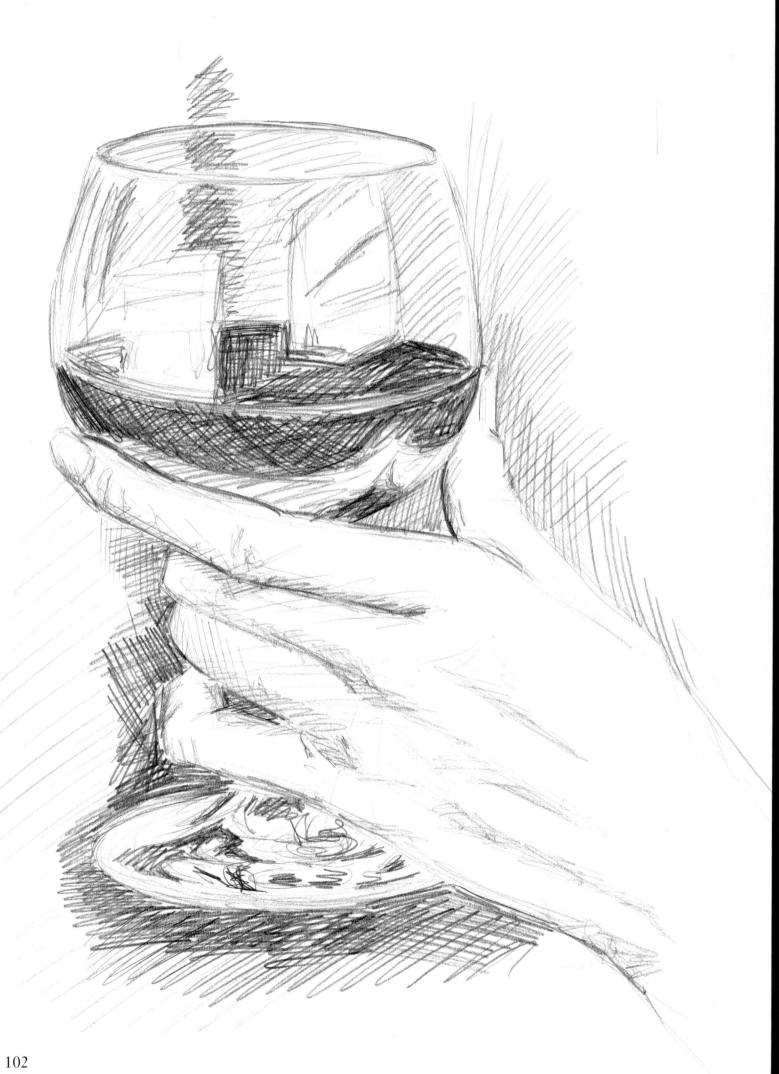

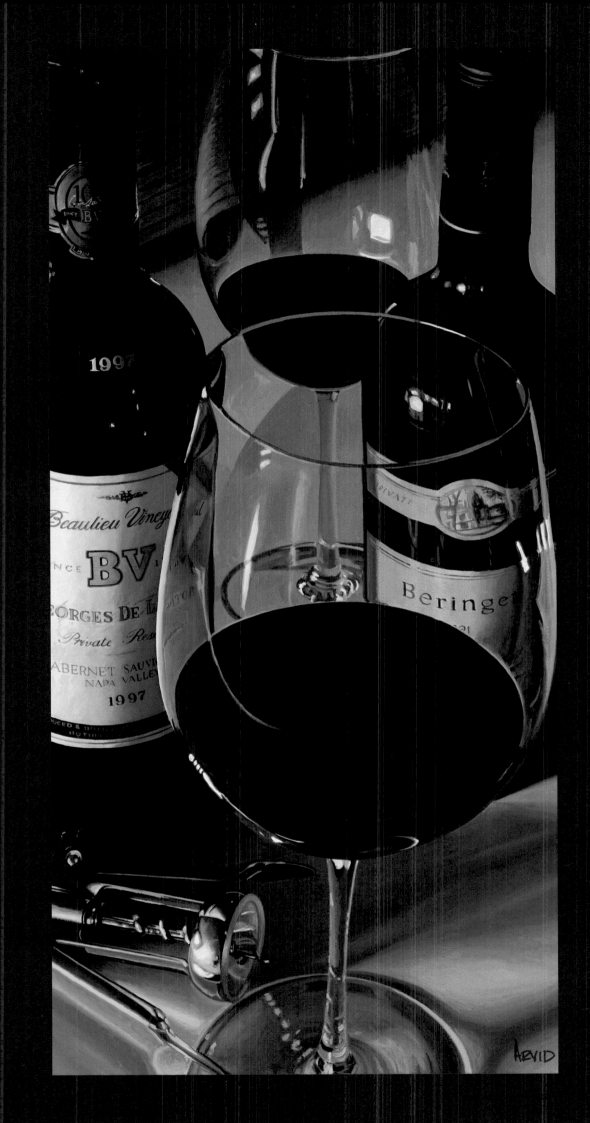

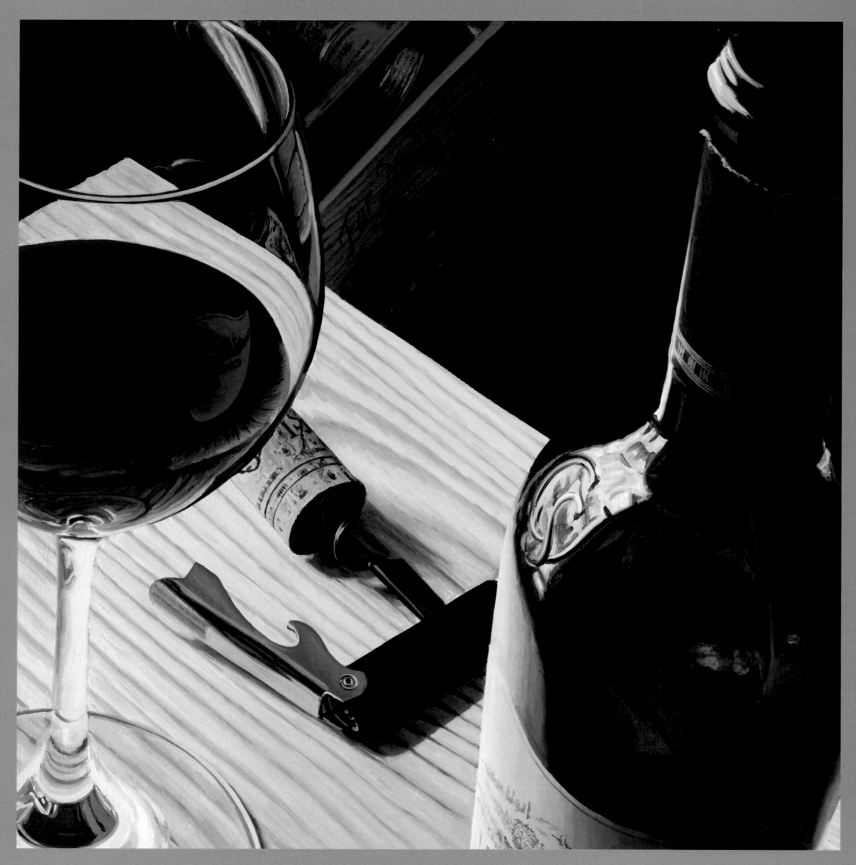

A Case of Mistaken Identity

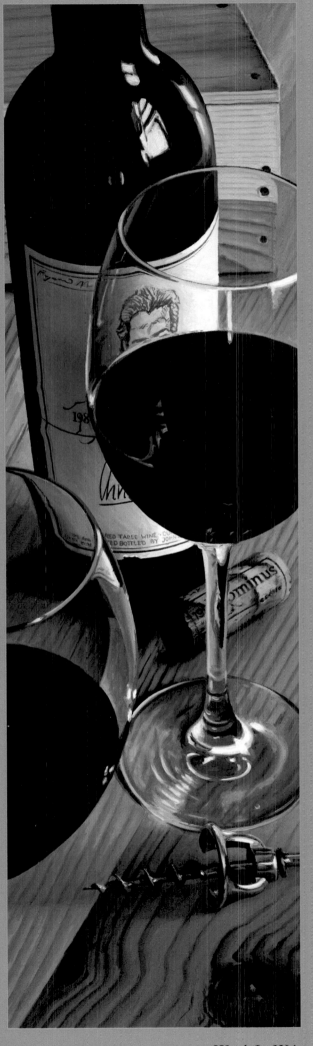

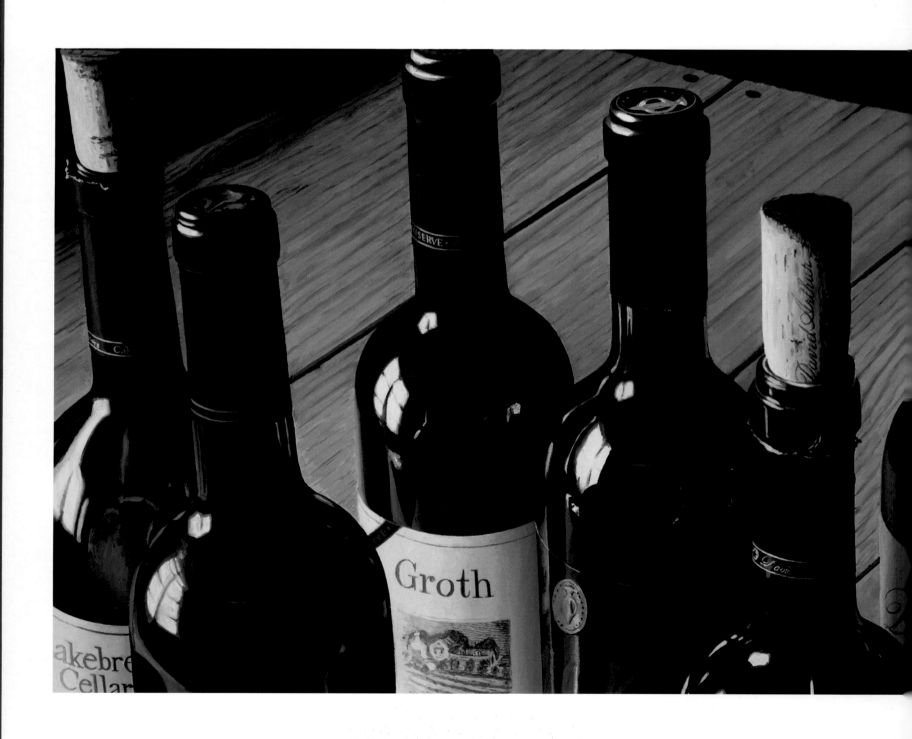

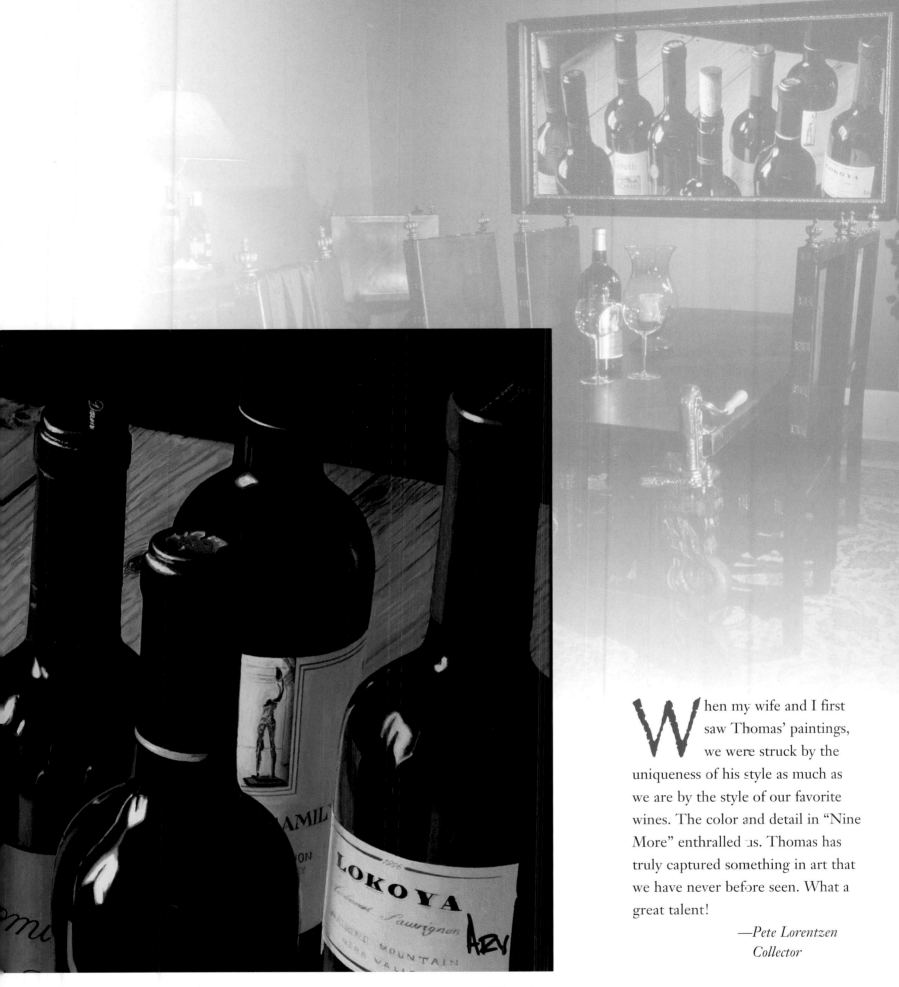

Nine More

When my wife and I first saw Thomas' paintings, we were struck by the uniqueness of his style as much as we are by the style of our favorite wines. The color and detail in "Nine More" enthralled us. Thomas has truly captured something in art that we have never before seen. What a great talent!

—*Pete Lorentzen*
Collector

107

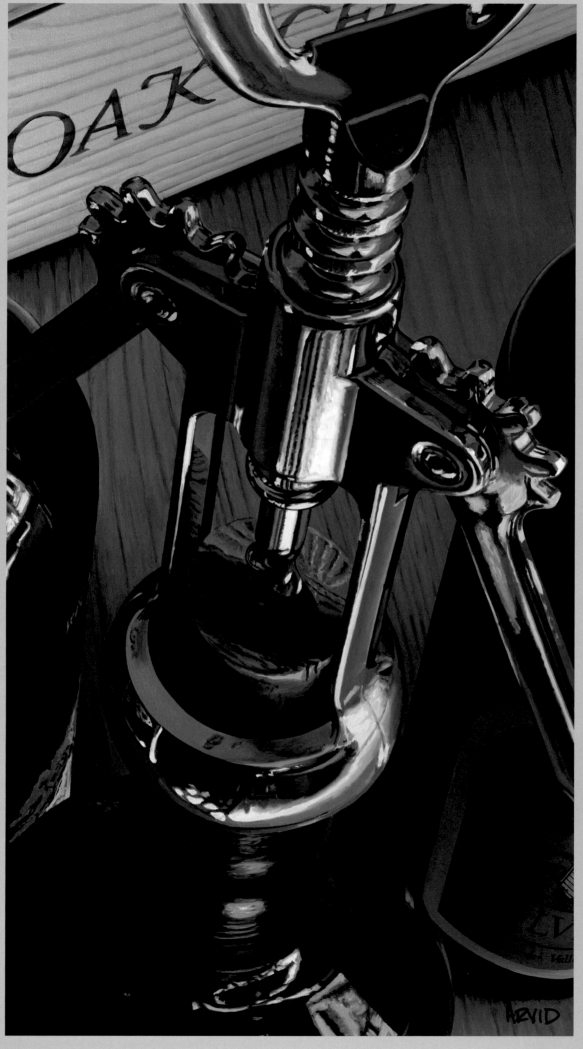

The Pull

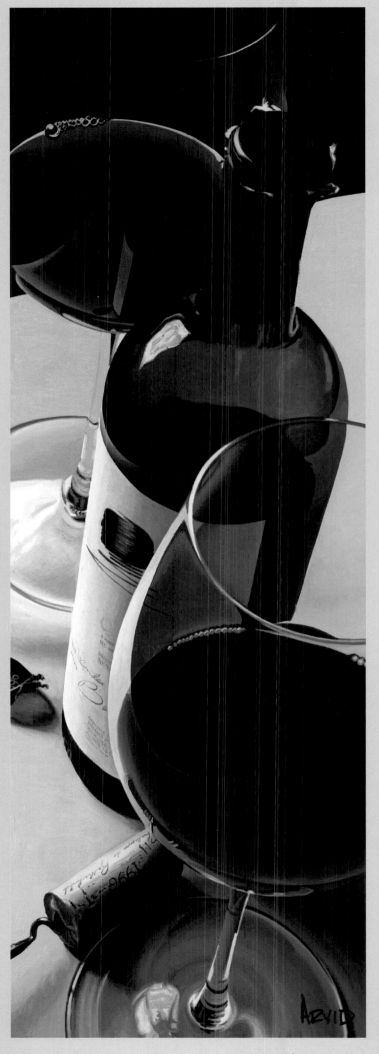

A Classic Setting

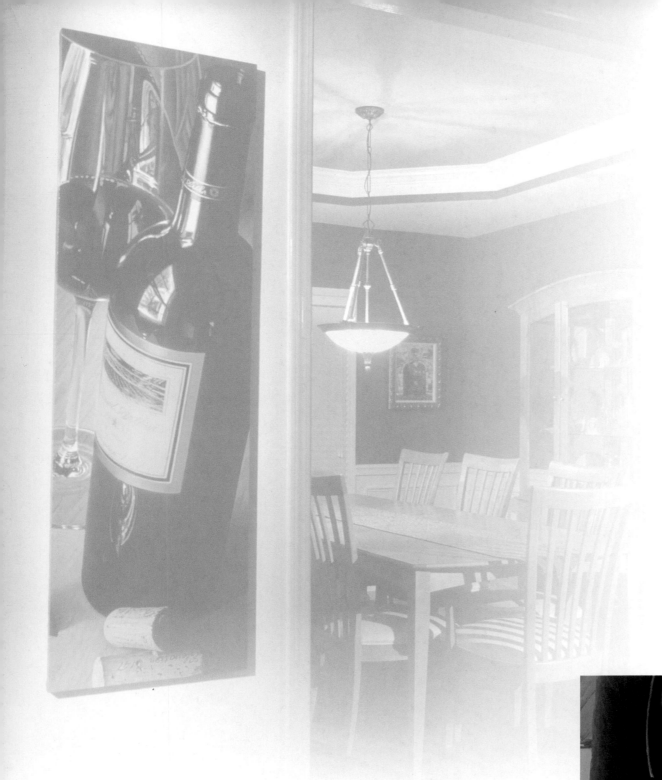

Every time I look at our "1147," I see another shadow, a different reflection, some subtle detail that I never noticed before. In many ways, our Arvid is reminiscent of a great wine in that each time you experience it, your senses note another subtlety or nuance that was never apparent before.

—*Jim Gannon*
Collector

"Elevation 1147" detail

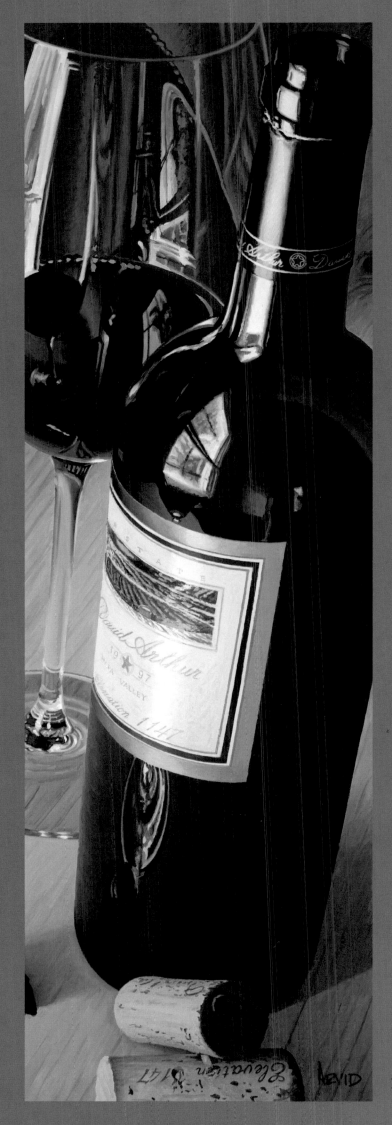

Elevation 1147

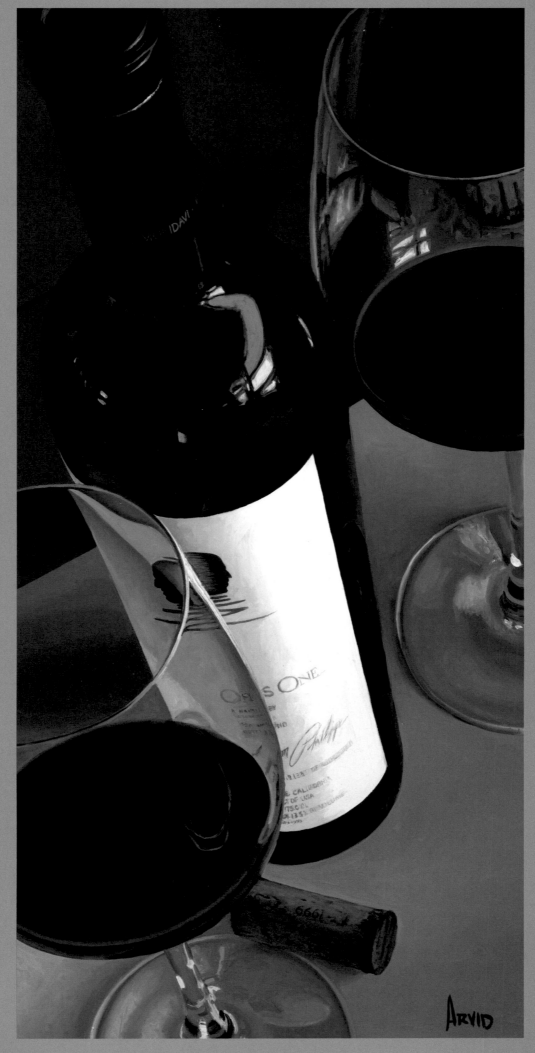

Between You & Me

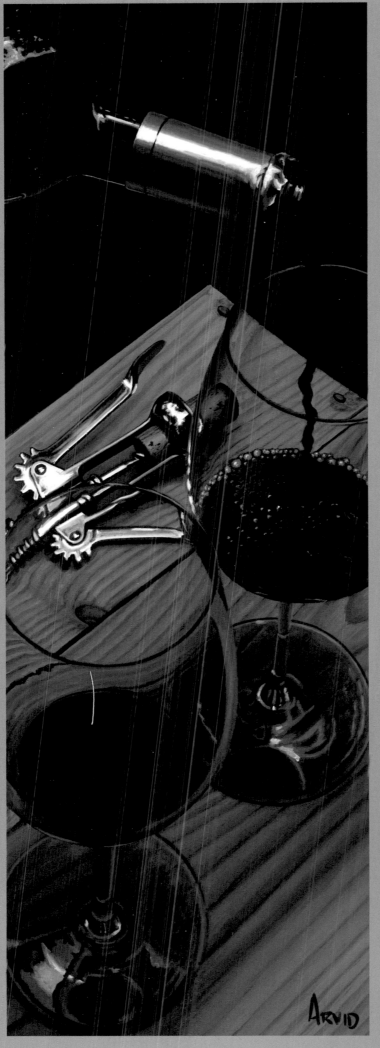

When It Rains

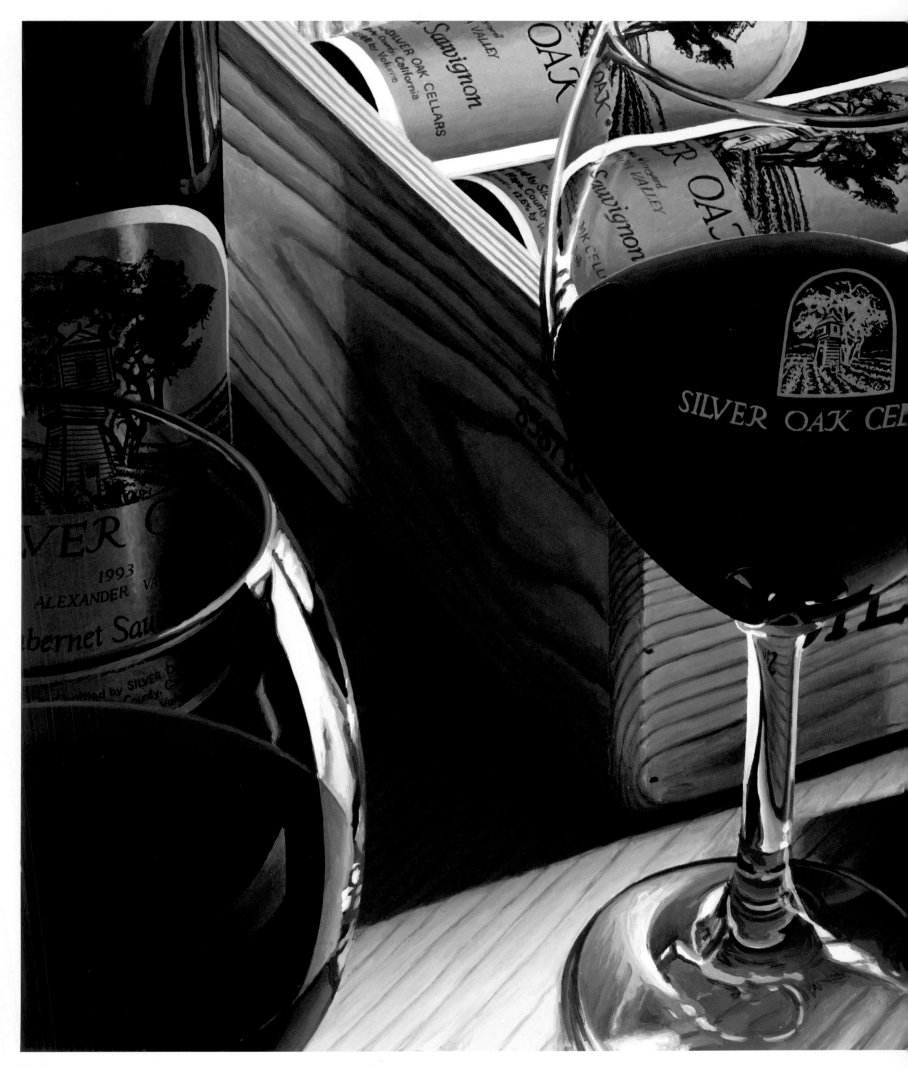

As a great artist, Thomas depicts wine on canvas, just as our winemaker, Daniel Baron, is an artist that creates wine in the bottle. The combination makes the wine linger in the memory forever.

—*Tom Johnson*
Silver Oak Cellars

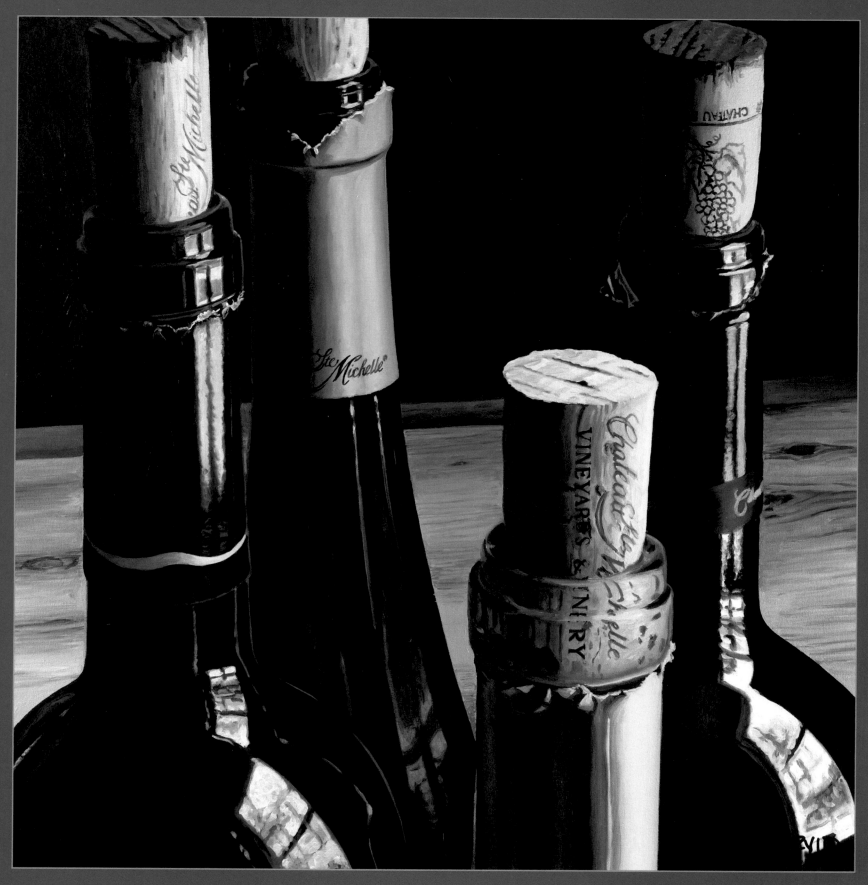

Michelle's Four

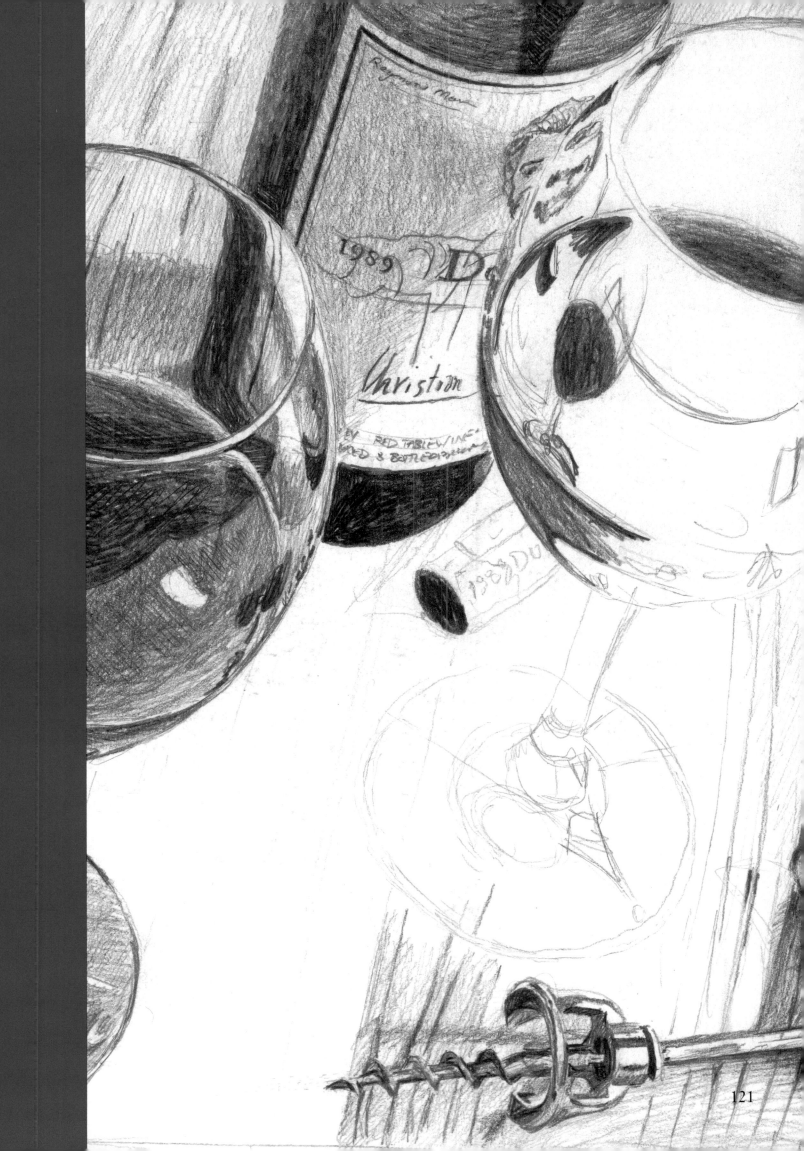

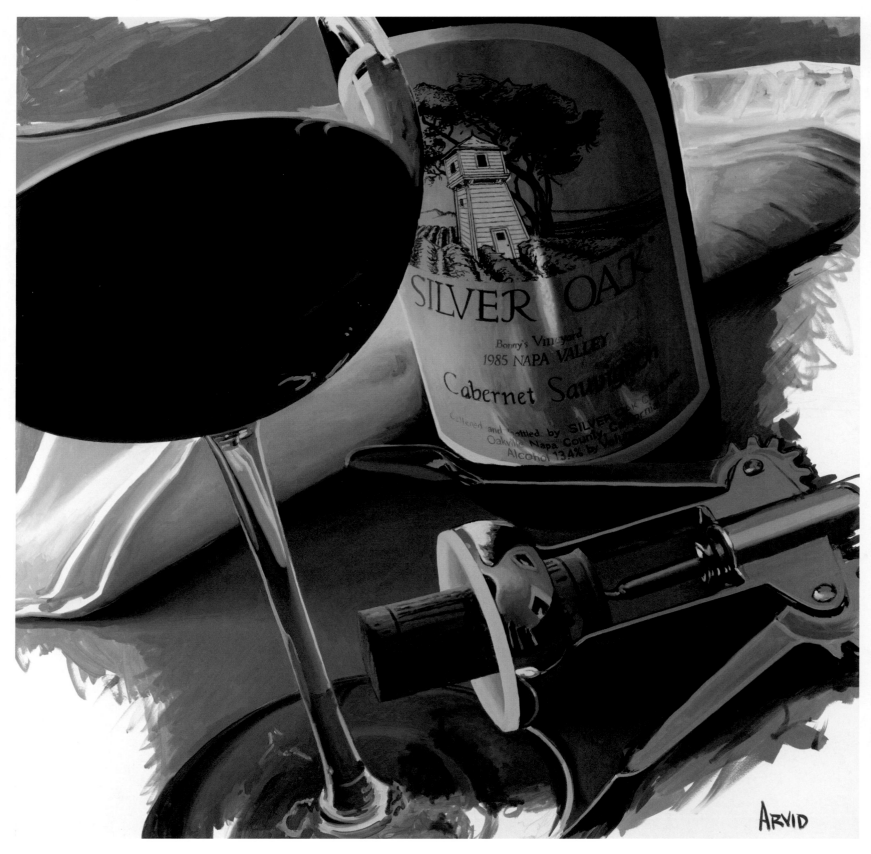

Rough Around the Edges

I didn't just get lazy and leave this piece unfinished. The whole idea about doing a painting like this was to leave it undone and a little raw so that you see the rough brushstrokes around the edge, see the raw and unpainted canvas. I liked the idea of having it partially there because I wonder about the line that I cross in my paintings that makes people literally see them as wine: as a two-dimensional illusion of wine. It is wine, but it isn't, and at what point does the piece fool you into thinking that it's wine? When does just a painting become wine itself? I tried to walk that line in this piece, to let the viewer explore that thought and the experience of painting it.

Eight Empties

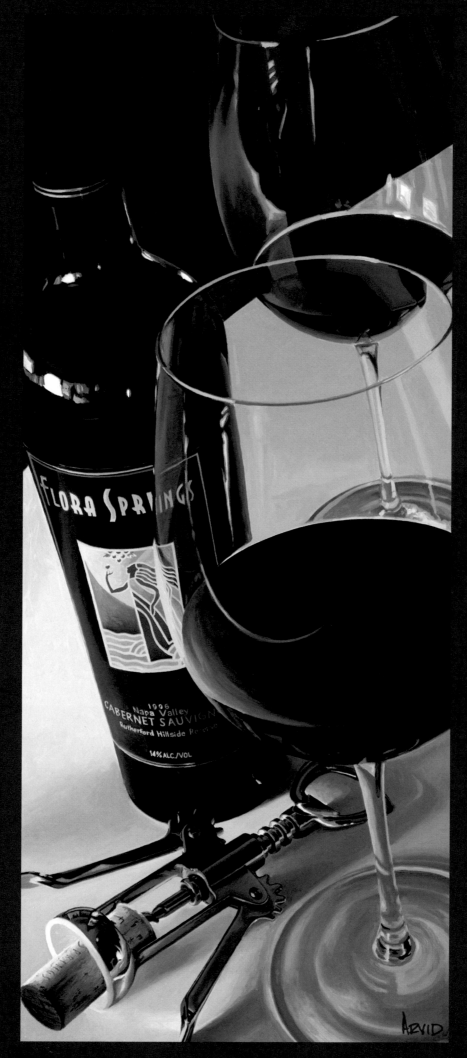

A Nice Bouquet

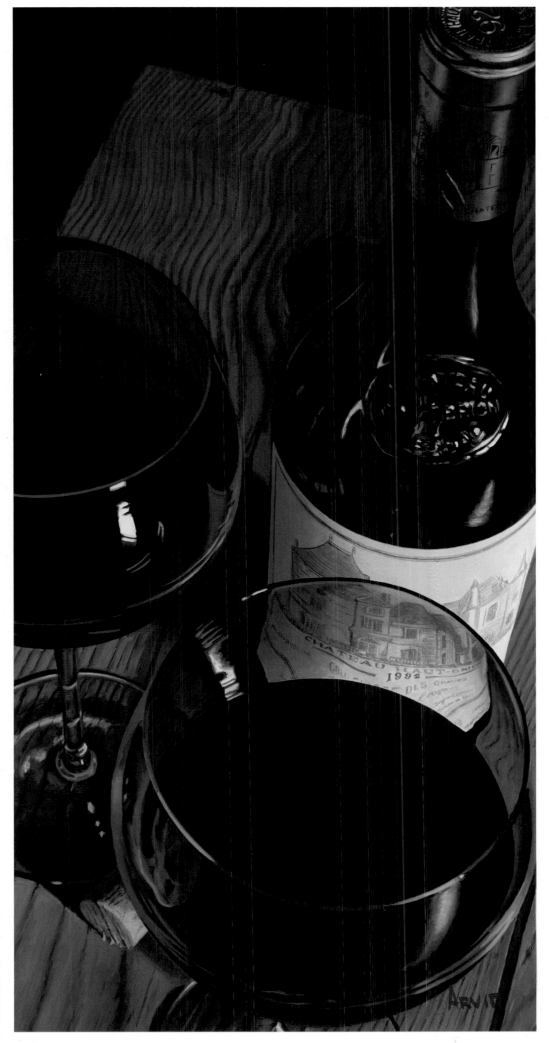

Best for Last

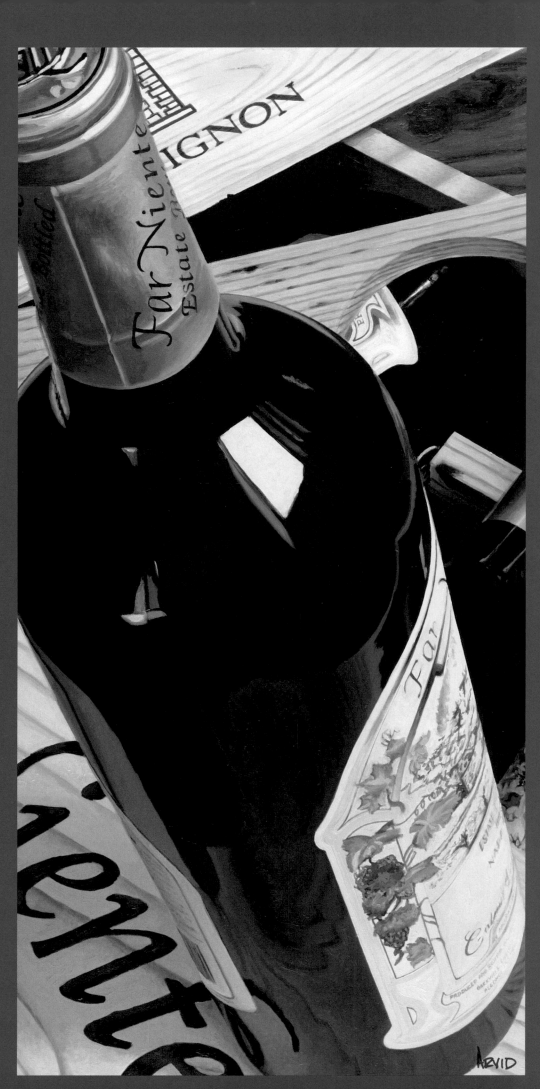

From a Case

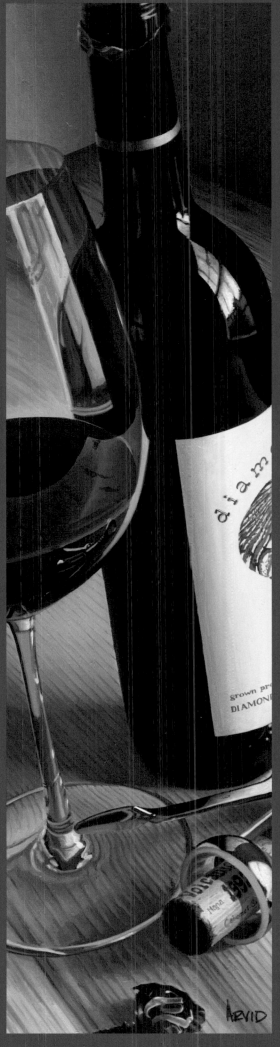

Little Diamond

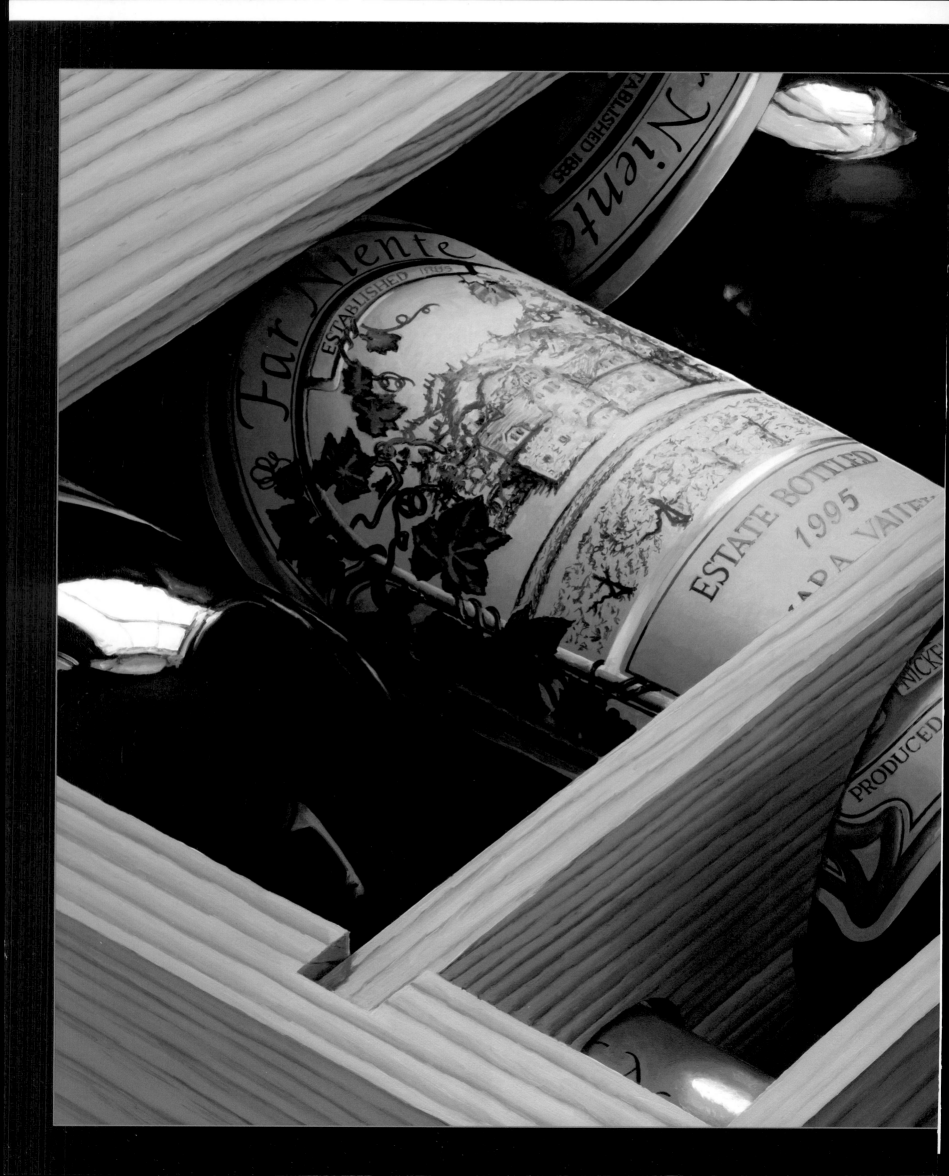

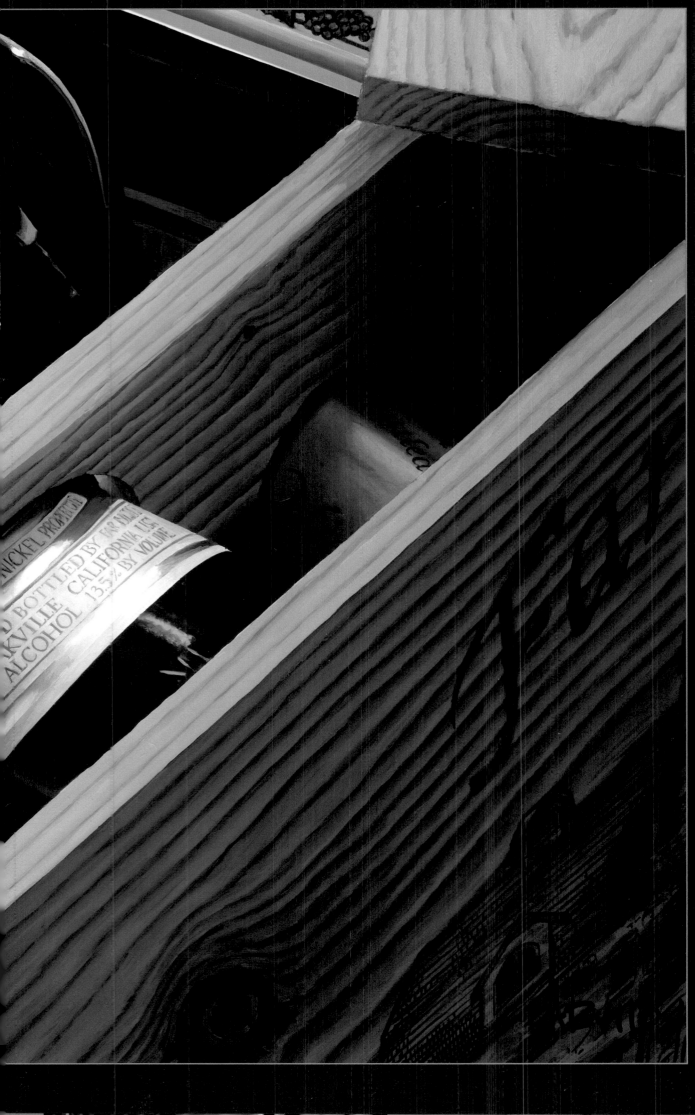

Autograph, anyone?

Thomas and Vanessa at their first California Show.

135

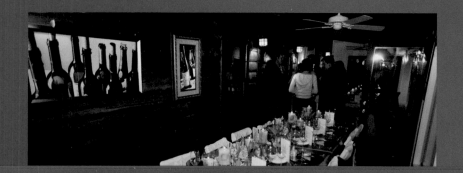

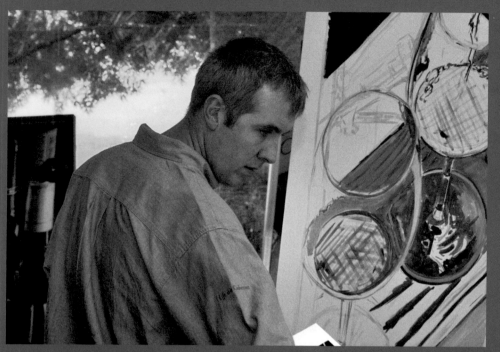

Laying in a painting at a Silver Oak Release.

Jimmy Arvid living it up at the Ritz!

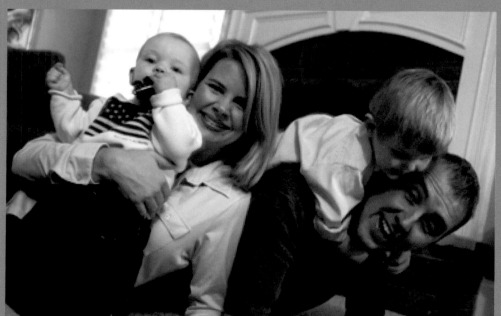

Thomas and family clowning around.

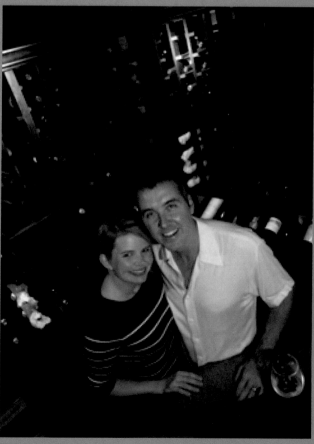

Thomas and Vanessa in their wine cellar.

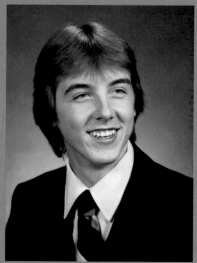

Thomas Arvid, age 18.

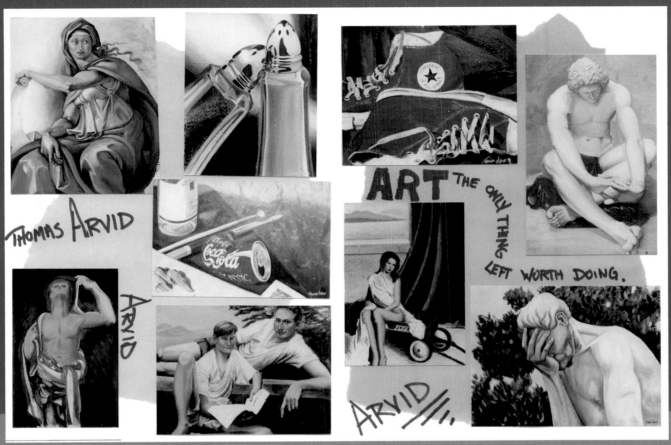

Arvid's first brochure.

Little Cat Arvid hard at work at "The Cabin."

Thomas Arvid, age 8.

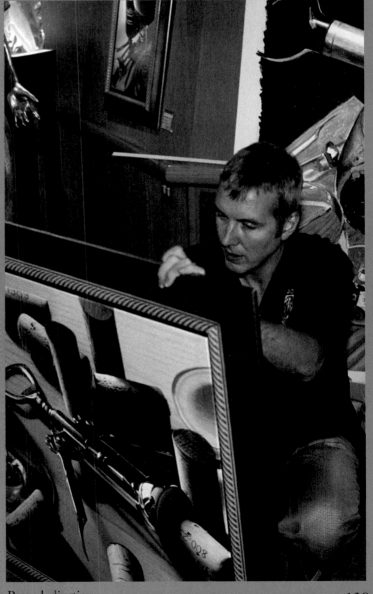

Pure dedication.